# PRINT'S BEST LETTERHEADS & BUSINESS CARDS 3

Manufactured in Singapore

## PRINT'S BEST LETTERHEADS & BUSINESS CARDS 3

Library of Congress Catalog Card Number 89-091067
ISBN 0-915734-84-2

## RC PUBLICATIONS

President and Publisher: Howard Cadel
Vice President and Editor: Martin Fox
Creative Director: Andrew Kner
Managing Director, Book Projects: Linda Silver
Associate Art Director: Nell Coyle
Administrative Assistant: Nancy Silver

# Print's Best
# LETTERHEADS & BUSINESS CARDS
## WINNING DESIGNS FROM PRINT MAGAZINE'S NATIONAL COMPETITION

Edited by

**LINDA SILVER**

Designed by

**ANDREW KNER**

Introduction by

**MARGARET RICHARDSON**

Published by

**RC PUBLICATIONS, INC.**
**NEW YORK, NY**

Most mail is boring. Flipping though the daily assortment evokes no great thrill: lackluster paper usually with nondescript letterheads, bland business briefs with little design flair. Business cards, too, blend insignificantly into the Rolodex. So when PRINT's Regional Design Annual appears and demonstrates that some stationery is evocative of the sender and that the business cards featured are business with an edge, the reader wants more.

Here in *Print's Best Letterheads & Business Cards 3*, featuring award-winning work from recent editions of the Regional Annual, the opportunity to reflect on a national collection of the best in stationery systems, letterheads, business cards, and corollary visuals, is inspiring and provocative, especially as the work is presented more opulently in this generous book format. In the 160 examples shown, flair flourishes.

The key to good stationery or a good business card is appropriateness. The design captures in one glance the essential message of the sender. What the firm does, its esthetic, its professionalism or its quirkiness, its efficiency and its personal touch are all projected and made memorable.

As usual in this kind of anthology, some images are repeated, the collective unconsciousness perhaps. Fruits and vegetables appear in abundance: Drop-shadowed apples seem inevitable for Apple Partners; romantic illustrations of grapes, a pear, and a wine glass capture the spirit of Italia (restaurant, deli, bakery, caterer, wine shop, and art gallery); cabbage and a potato provide an earthy introduction to Culinary Specialists, Inc.

Animals also loom large. Delicate equine illustrations portray the services of Sarah Clark dressage trainer/ instructor, and decorate the invoice for Reynard Printing. Illustrator Linda Schiwall-Gallo rather mysteriously presents a chicken and rooster on her stationery; and zoo animals appropriately appear on the stationery for the Hogle Zoo and the Utah Zoological Society. But the dominant animal here, whimsically for the most part, is the dog. For Cairn House,

# CONTENTS

Cairn Terrier Breeder, both the dogs and the house are the image. For Modern Dog, Bad Dog Design, and Laughing Dog Creative, Inc., the canine shows attitude.

As usual, design firms use every printed piece of their stationery to show off what they do best. With every mail delivery, well-established design firms like "RED" design in Seattle and Vaughn/Wedeen in Albuquerque remind everyone that they are still doing first-rate work.

Varied interpretations of film, cameras, and frames are staple images for photographers' stationery—for example, for Craig Cutler Studio, Stanley Rowan Photography, Stewart Tilger Photography, and Jean Shieves Photography.

Other design attributes should be mentioned here. Along with the ideas and imagery, this stationery is memorable for its excellent paper selection with very deliberate weights, textures, weaves, and colors. Outstanding use of a two-sided color effect can be seen in the stationery for Workouts, Inc., New Jersey State Aquarium, and Hess Design. Type, when used, is carefully crafted and kerned and letterforms convey identities for Elika (luxury product design) and Ostro Design, among others.

Clients expect designers to transmit what they offer in dramatic or telegraphic ways. The effect of these collected pieces are hints of elegance, effective witticisms, strong statements of intent, advertisements for significant services, and business clout. This assortment of design styles avoids a corporate clone quality, reflects a regionalism and spunkiness, and makes business correspondence appealing.

The editors and art director of PRINT chose these splendid examples from the many hundreds they received, and this book should serve as an important reference as well as an inspiration for anyone designing for business.

—*Margaret Richardson*

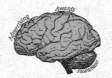

*Ad*·vertising *Sa*·vànts, Inc.

7536 Forsyth Blvd., Suite 123
St. Louis, MO 63105

**DESIGN FIRM:**

Advertising Savants, Inc.,

St. Louis, Missouri

**ART DIRECTOR:**

Bob Gartland

**COPYWRITER:**

Anne Gartland

**ILLUSTRATOR:**

*Grey 's Anatomy*

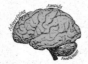

*Ad*·vertising *Sa*·vànts, Inc.

7536 Forsyth Blvd., Suite 123
St. Louis, MO 63105

*Real Cerebral Stuff.*

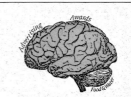

*Ad*·vertising *Sa*·vànts, Inc.

Robert Gartland
Principal/Creative Director

7536 Forsyth Blvd., Suite 123
St. Louis, MO 63105
(314) 863-8326

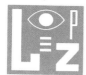

DESIGN FIRM:

Ph.D., Santa Monica,

California

ART DIRECTORS:

Clive Piercy, Michael

Hodgson

DESIGNER/ILLUSTRATOR:

Clive Piercy

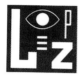

**B R E T  L O P E Z**

**B R E T  L O P E Z**

533 Moreno Avenue, Los Angeles, California 90049 [213] 393 8841 fax [213] 393 7304

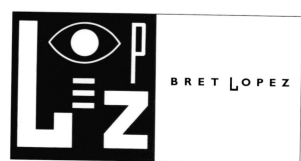

**B R E T  L O P E Z**

PHOTOGRAPHER

533 Moreno Ave.

Los Angeles

California 90049

[213] 393 8841

fax [213] 393 7304

**B R E T  L O P E**

**7**

Du Pont Company
Laurel Run Building, 2N17
P. O. Box 80705
Wilmington, DE 19880-0705

THE DU PONT INVITATIONAL GOLF OUTING
At The McDonald's Championship

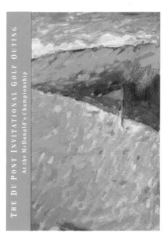

THE DU PONT

INVITATIONAL

GOLF OUTING

At The McDonald's Championship

THE DU PONT INVITATIONAL GOLF OUTING
At The McDonald's Championship
June 21 & 22

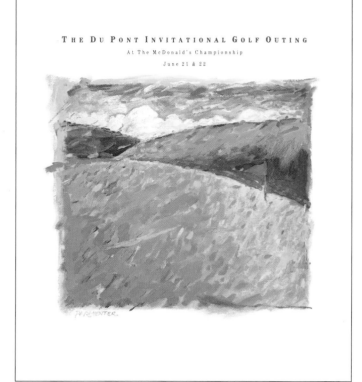

**SPEND THREE DAYS IN THE MAGNIFICENT BRANDYWINE RIVER VALLEY**

From the excursions listed below, choose one for each day:

**Wednesday, June 21** ☐ **"A Day in Old New Castle"**—(Sites include—George Reed House, Old Swedes Church and lunch at the David Finney Inn)

☐ **"Excursion to Château Country"**—(Tours include—Nemours Mansion and Gardens and Winterthur Museum and Gardens)

**Thursday, June 22** ☐ **"The Philadelphia Liberty Tour"**—(A tour of historic Philadelphia)

☐ **"The Classic Boutique Outing"**—(Shop in the area's most chic stores in neighboring Greenville, Centerville and Hockessin; antiquing can be done on request)

**Friday, June 23** ☐ **"Excursion to Château Country Revisited"**—(Tours include Winterthur's American Craftsmanship Tour and a tour of Nemours Mansion and Gardens)

☐ **"Life on the Brandywine River"**—(A complete tour of the Hagley Museum)

*Please mail your selections in by May 30 Thank you*

Name _____

Address _____ Phone _____

Special event stationery.

DESIGN FIRM:

Janet Hughes and

Associates, Wilmington,

Delaware

CREATIVE DIRECTOR:

Donna Perzel

ART DIRECTOR:

Paul DiCampli

DESIGNER: Mark Lee

ILLUSTRATOR:

Wayne Parmenter

ACCOUNT SUPERVISOR:

Janet Hughes

THE DU PONT INVITATIONAL GOLF OUTING

At The McDonald's Championship

Du Pont

PRODUCING

POLISHED WORK

C. WOODMANSEE PRODUCTIONS
5697 SOUTH MAPLEWOOD DRIVE
SOUTH OGDEN, UTAH 84405
801-476-9524 FAX 801-479-3423

DESIGN FIRM:

Wilde & Stein, Layton, Utah

ART DIRECTOR/

DESIGNER/ILLUSTRATOR:

Dave Stein

## C. Woodmansee Productions (Video Production)

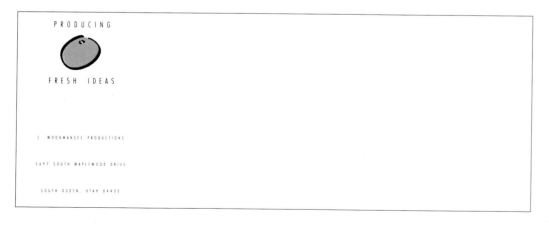

PRODUCING

FRESH IDEAS

C  WOODMANSEE PRODUCTIONS

5697 SOUTH MAPLEWOOD DRIVE

SOUTH OGDEN, UTAH 84405

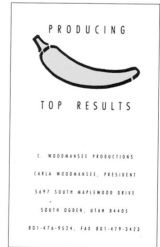

PRODUCING

TOP RESULTS

C. WOODMANSEE PRODUCTIONS

CARLA WOODMANSEE, PRESIDENT

5697 SOUTH MAPLEWOOD DRIVE

SOUTH OGDEN, UTAH 84405

801-476-9524, FAX 801-479-3423

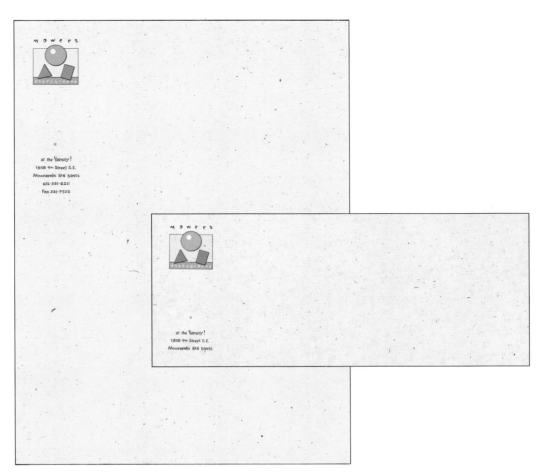

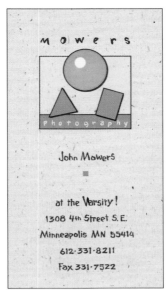

## Mowers Photography

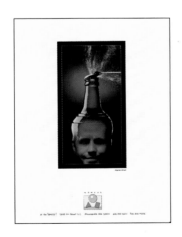

DESIGN FIRM: ArtVille, Inc.,

Minneapolis, Minnesota

ART DIRECTOR/

ILLUSTRATOR:

Matt McKenzie

DESIGNERS: J. Campbell,

Matt McKenzie,

TYPOGRAPHER:

J. Campbell

DESIGN FIRM:

The Pushpin Group, New

York, New York

ART DIRECTOR/DESIGNER:

Greg Simpson

CRAIG CUTLER STUDIO, INC.
628-30 BROADWAY
NEW YORK, NY 10012
PHONE 212·473·2892
FAX 212·473·8306

CRAIG CUTLER STUDIO, INC.

PHONE 212·473·2892

FAX 212·473·8306

CRAIG CUTLER STUDIO, INC.

628·30 BROADWAY

NEW YORK, NY 10012

CRAIG CUTLER STUDIO, INC.

628·30 BROADWAY

NEW YORK, NY 10012

CRAIG CUTLER STUDIO, INC

628·30 BROADWAY

NEW YORK, NY 10012

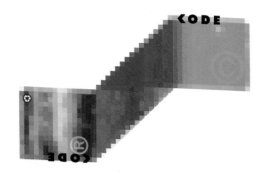

DESIGN FIRM:

KODE Associates, Inc.,

New York, New York

ART DIRECTOR/

DESIGNER/ILLUSTRATOR:

William Kochi

## KODE Associates, Inc.

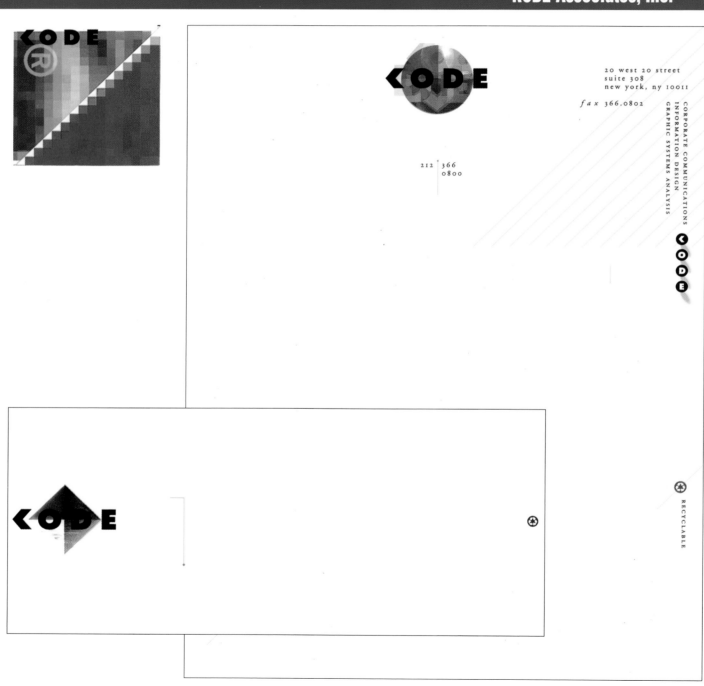

20 west 20 street
suite 308
new york, ny 10011

fax 366.0802

212 366
0800

CORPORATE COMMUNICATIONS
INFORMATION DESIGN
GRAPHIC SYSTEMS ANALYSIS

RECYCLABLE

**Pet Medic Corporation**
996 Main Street
Evanston, Illinois 60202
312/869 9828

**Pet Medic Corporation**
966 Main Street
Evanston, Illinois 60202
312 869 9828

**PET MEDIC**™

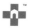

**Pet Medic Corporation**
996 Main Street
Evanston, Illinois 60202

**PET MEDIC**™

**PET MEDIC**™

DESIGN FIRM:

Michael Stanard, Inc.,

Evanston, Illinois

ART DIRECTOR/DESIGNER:

Michael Stanard

## Pet Medic Inc. (Pet Care Products)

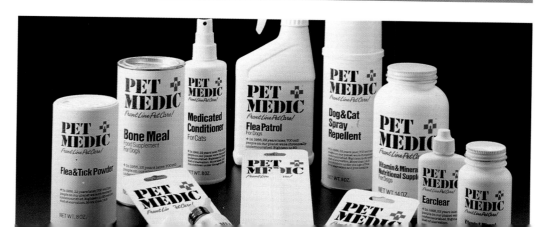

DESIGN FIRM:

Kurt Kaptur Design,

Lakewood , Ohio

ART DIRECTOR/DESIGNER:

Kurt Kaptur

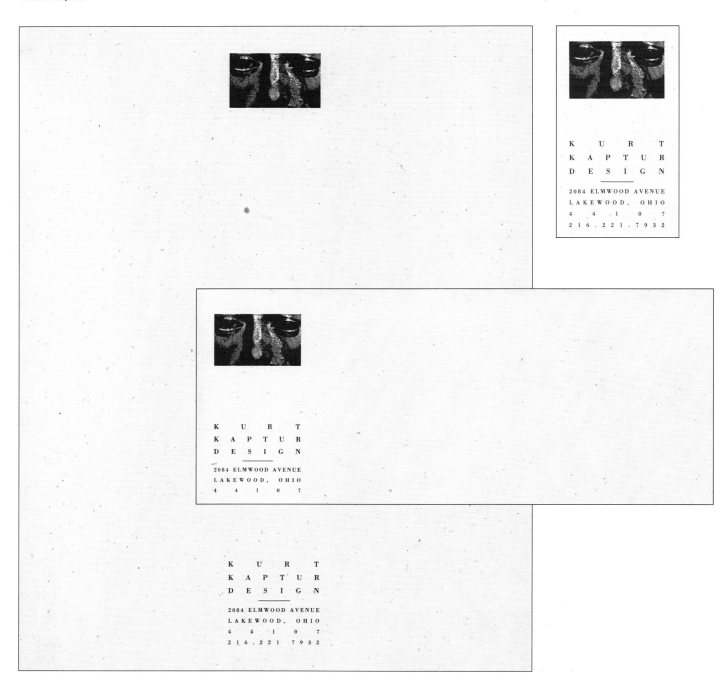

DESIGN FIRM:

The Martin-Behun

Company, Phoenix, Arizona

ART DIRECTORS:

Tom Martin, Jayce Behun

ILLUSTRATOR:

Roland G. Dahlquist

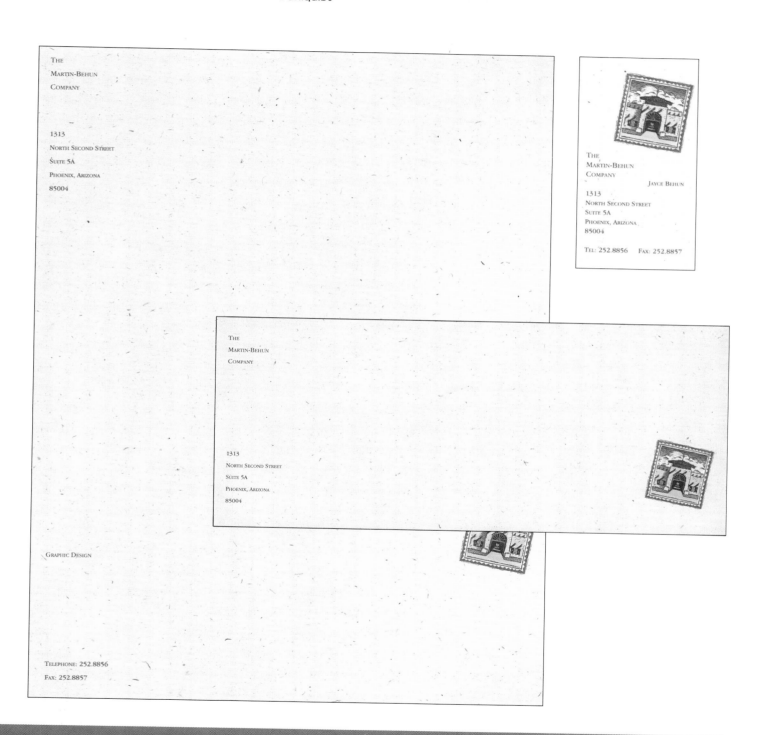

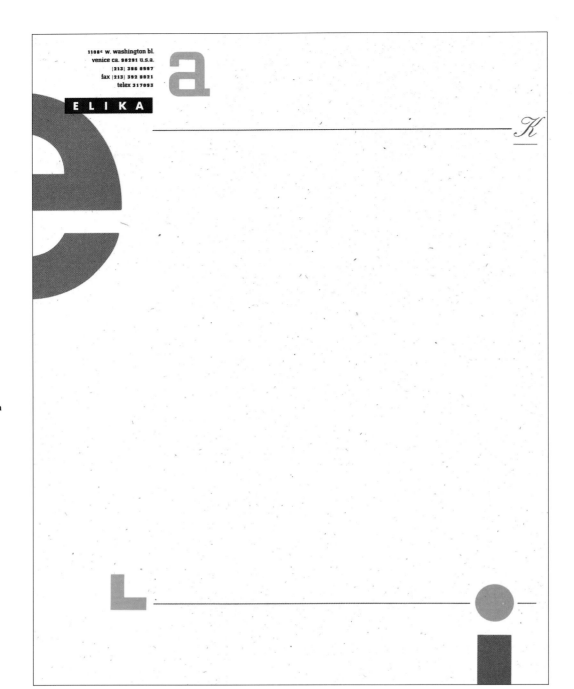

DESIGN FIRM: Ph.D, Santa
Monica, California
ART DIRECTORS:
Clive Piercy, Michael
Hodgson
DESIGNER: Clive Piercy

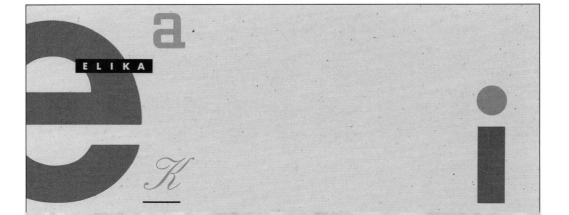

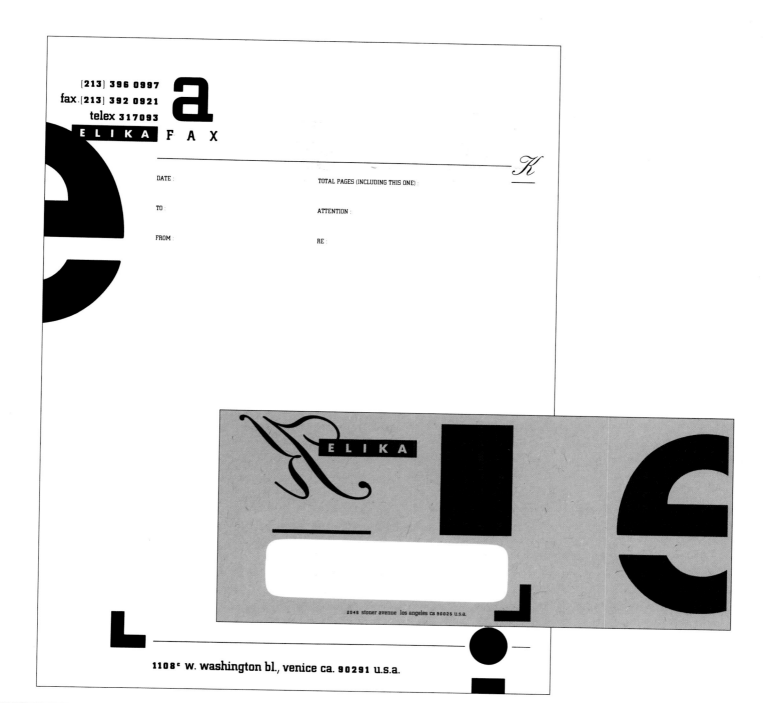

[213] 396 0997
fax.[213] 392 0921
telex 317093

**a**

**ELIKA** F A X

*K*

DATE :

TOTAL PAGES (INCLUDING THIS ONE) :

TO :

ATTENTION :

FROM :

RE :

**ELIKA**

2046 stoner avenue  los angeles ca 90025 u.s.a.

1108ᶜ w. washington bl., venice ca. 90291 u.s.a.

## Elika (Luxury Product Design)

**elik**a

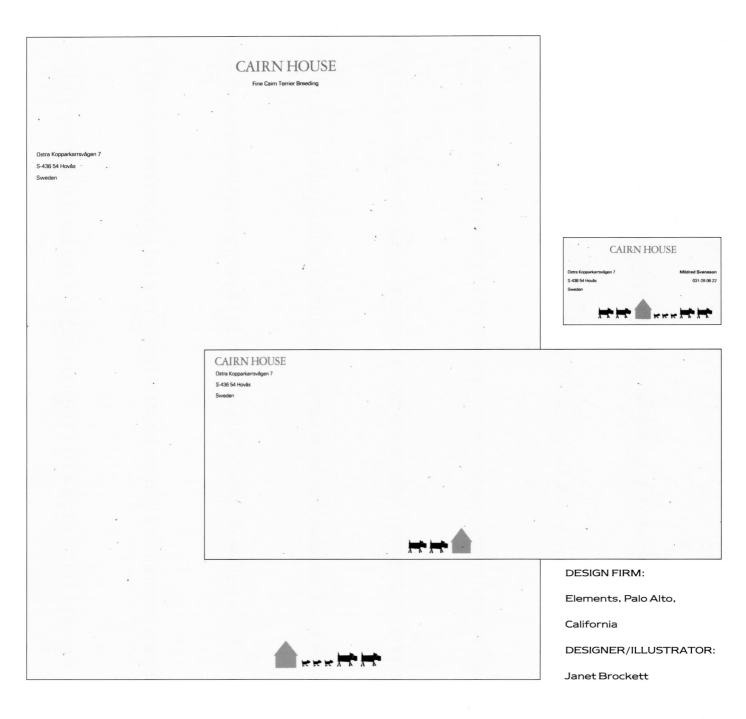

DESIGN FIRM:

Elements, Palo Alto,

California

DESIGN FIRM/ILLUSTRATOR:

Janet Brockett

**Cairn House (Cairn Terrier Breeder)**

DESIGN FIRM:

Eilts Anderson Tracy ,

Kansas City, Missouri

ART DIRECTOR/

DESIGNER/ ILLUSTRATOR:

Patrice Eilts

C          R          O          O          K          S

C     R     O     O     K     S

1510 LAKESTONE · OLATHE · KANSAS · 66061

1510 LAKESTONE · OLATHE · KANSAS · 66061 · 913.829.6564

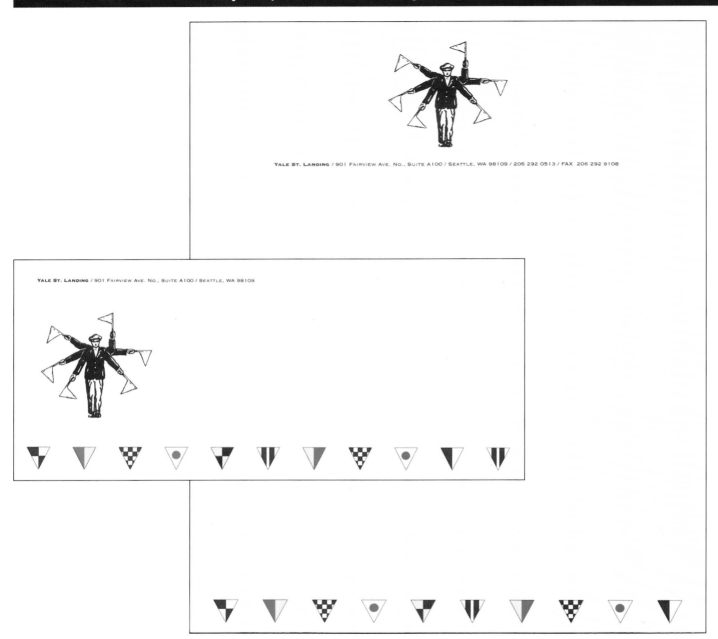

YALE ST. LANDING / 901 FAIRVIEW AVE. NO., SUITE A100 / SEATTLE, WA 98109 / 206 292 0513 / FAX 206 292 9108

YALE ST. LANDING / 901 FAIRVIEW AVE. NO., SUITE A100 / SEATTLE, WA 98109

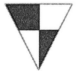

DESIGN FIRM:

The Leonhardt Group,

Seattle, Washington

ART DIRECTOR:

Rick Hess

DESIGNERS: Rick Hess,

Mike Bold

ILLUSTRATOR:

Tim Young

Corporate meeting and
event planners focusing on
U.S. Virgin Islands.

DESIGN FIRM:

Jager Di Paola Kemp
Design, Burlington,
Vermont

ART DIRECTOR:

Michael Jager

DESIGNERS/ILLUSTRATORS:

JeanMarie Norton,
Anthony Sini

P.O. Box 12319

St. Thomas

U.S. Virgin Islands 00801

TEL
809.776.3650

FAX
809.775.7602

CARIBBEAN

TOUR

SERVICES

**Caribbean Tour Services**

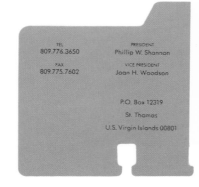

TEL
809.776.3650

FAX
809.775.7602

PRESIDENT
Phillip W. Shannon

VICE PRESIDENT
Joan H. Woodson

P.O. Box 12319

St. Thomas

U.S. Virgin Islands 00801

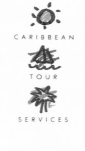

CARIBBEAN

TOUR

SERVICES

24

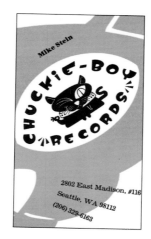

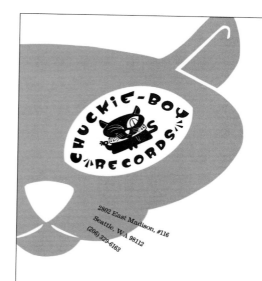

DESIGNER: Art Chantry,

Seattle, Washington

ILLUSTRATOR:

Peter Bagge

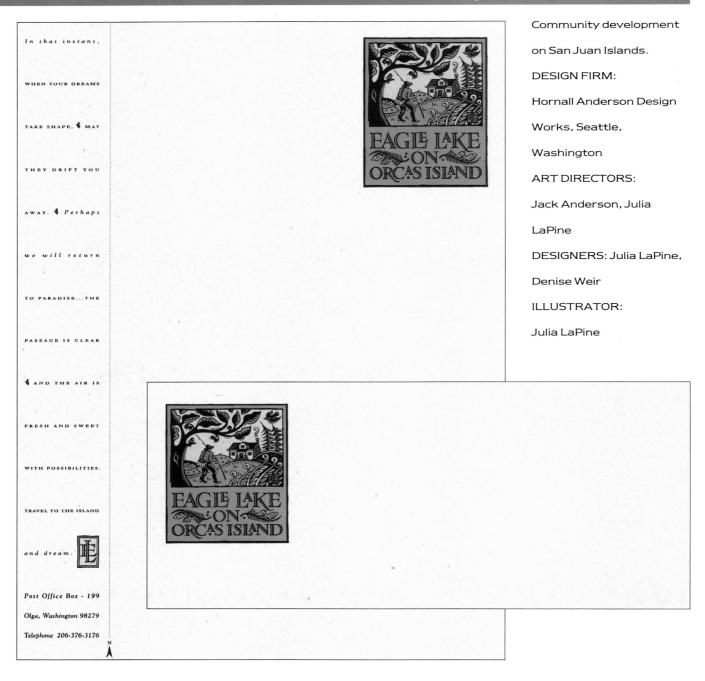

*In that instant,*

WHEN YOUR DREAMS

TAKE SHAPE, ✦ MAY

THEY DRIFT YOU

AWAY. ✦ *Perhaps*

*we will return*

TO PARADISE...THE

PASSAGE IS CLEAR

✦ AND THE AIR IS

FRESH AND SWEET

WITH POSSIBILITIES.

TRAVEL TO THE ISLAND

*and dream.*

*Post Office Box - 199*

*Olga, Washington 98279*

*Telephone 206-376-3176*

Community development on San Juan Islands.
DESIGN FIRM:
Hornall Anderson Design Works, Seattle, Washington
ART DIRECTORS:
Jack Anderson, Julia LaPine
DESIGNERS: Julia LaPine, Denise Weir
ILLUSTRATOR:
Julia LaPine

F. SANDY DESNER

EAGLE LAKE On Orcas Island
*In that instant,* ✦ WHEN YOUR
DREAMS TAKE SHAPE, MAY THEY
DRIFT YOU AWAY. ✦ *Perhaps* WE WILL
RETURN TO PARADISE...THE PASSAGE
IS CLEAR AND THE AIR IS FRESH
AND SWEET WITH POSSIBILITIES. ✦
TRAVEL TO THE ISLAND *and dream.*

*Address: Post Office Box - 199*
*Olga, Washington 98279*
*Telephone: 206-376-3176*

F. SANDY DESNER

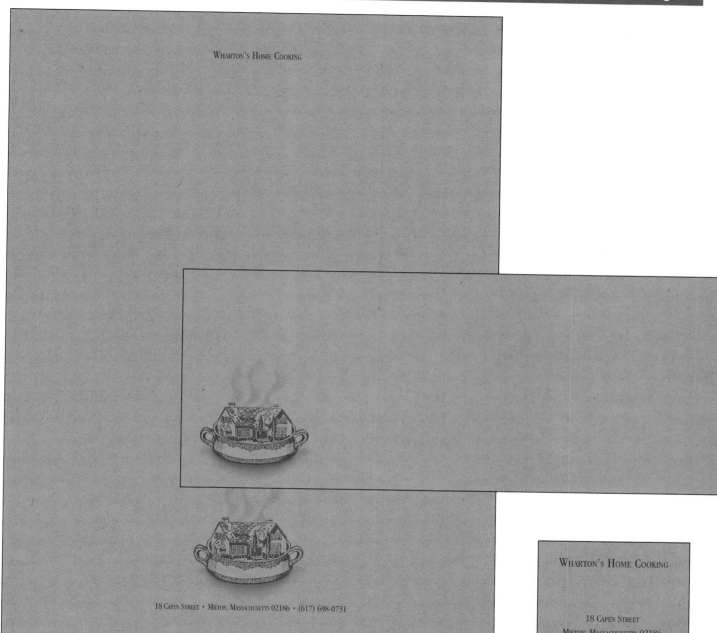

WHARTON'S HOME COOKING

18 Capen Street • Milton, Massachusetts 02186 • (617) 698-0731

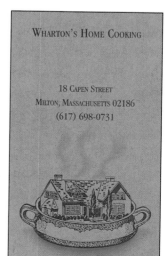

WHARTON'S HOME COOKING

18 Capen Street
Milton, Massachusetts 02186
(617) 698-0731

David Wharton is a chef who comes into your home to prepare meals.

**DESIGN FIRM:**

Thomas Neville Graphic Design, Newton Upper Falls, Massachusetts

**ART DIRECTORS/ DESIGNERS:**

Thomas Neville, Janet Palasek

**AIRBRUSH ARTIST:**

Dave Stern

DESIGN FIRM:

Hornall Anderson Design

Works, Seattle, Washington

ART DIRECTOR:

John Hornall

DESIGNERS:

John Hornall, David Bates

**Stewart Tilger Photography**

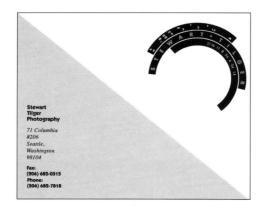

Stewart
Tilger
Photography

71 Columbia
#206
Seattle,
Washington
98104

Fax:
(206) 682-0515
Phone:
(206) 682-7818

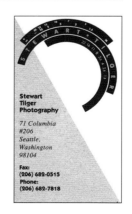

Stewart
Tilger
Photography

71 Columbia
#206
Seattle,
Washington
98104

Fax:
(206) 682-0515
Phone:
(206) 682-7818

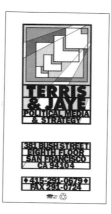

Advertising agency specializing in political campaigns.

AGENCY: Terris & Jaye, Media & Strategy, San Francisco, California

ART DIRECTOR / DESIGNER: Gar Moss

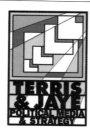

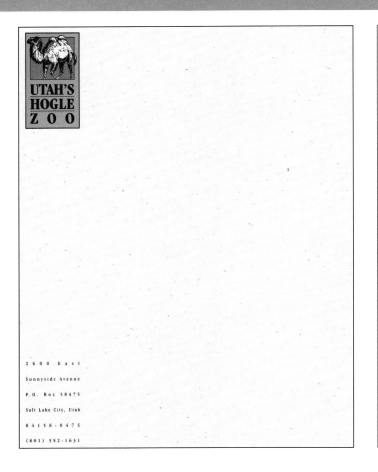

2 6 0 0   E a s t

Sunnyside Avenue

P.O.  Box  58475

Salt Lake City, Utah

8 4 1 5 8 - 0 4 7 5

(801)  582-1631

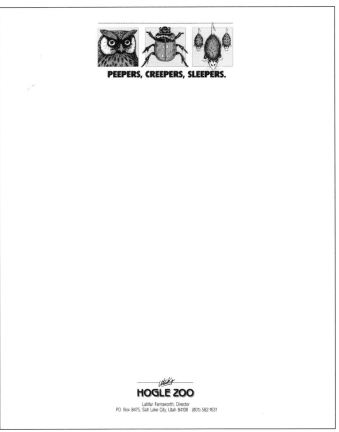

PEEPERS, CREEPERS, SLEEPERS.

*Utah's*
HOGLE ZOO
LaMar Farnsworth, Director
P.O. Box 8475, Salt Lake City, Utah 84108   (801) 582-1631

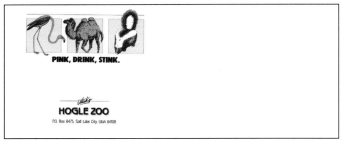

PINK, DRINK, STINK.

*Utah's*
HOGLE ZOO
P.O. Box 8475, Salt Lake City, Utah 84108

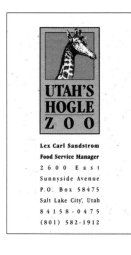

UTAH'S
HOGLE
Z O O

**Lex Carl Sandstrom**
**Food Service Manager**
2 6 0 0   E a s t
Sunnyside Avenue
P.O.  Box  58475
Salt Lake City, Utah
8 4 1 5 8 - 0 4 7 5
(801)  582-1912

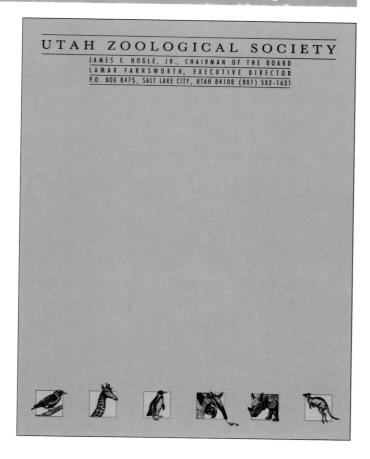

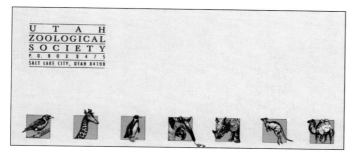

Stationery for the Hogle

Zoo and the Utah

Zoological Society.

DESIGN FIRM:

Fotheringham &

Associates, Salt Lake City,

Utah

ART DIRECTOR/ DESIGNER:

Paul Christensen

ILLUSTRATOR:

Randy Stroman

CREATIVE DIRECTOR:

Bruce Jensen

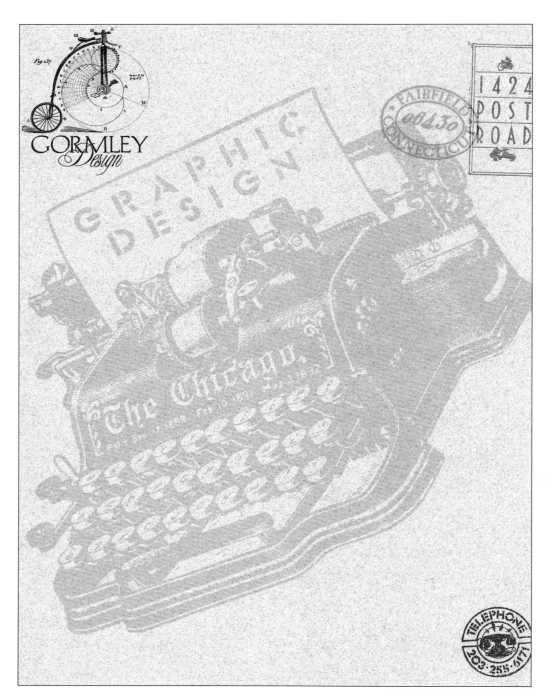

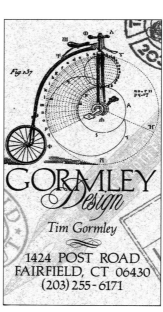

Tim Gormley

1424 POST ROAD
FAIRFIELD, CT 06430
(203) 255-6171

DESIGN FIRM:

Gormley Design, Fairfield,

Connecticut

DESIGNER: Tim Gormley

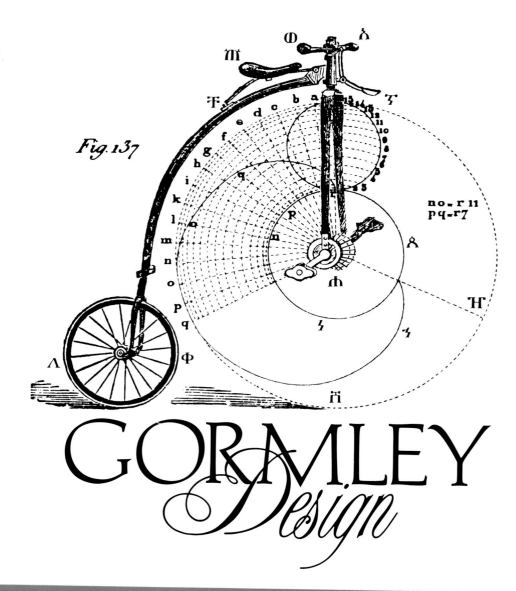

*Richard Peterson Photography,* 7660 Washington Avenue South, Minneapolis, Minnesota 55344. Fax: 943-2407. 612/943-2404

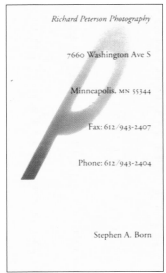

*Richard Peterson Photography*

7660 Washington Ave S

Minneapolis, MN 55344

Fax: 612/943-2407

Phone: 612/943-2404

Stephen A. Born

DESIGN FIRM:

Eaton & Associates,

Minneapolis, Minnesota

DESIGNER: Mike Haug

*Richard Peterson Photography,* 7660 Washington Avenue South, Minneapolis, Minnesota 55344.

DESIGN FIRM:

Eaton & Associates,

Minneapolis, Minnesota

DESIGNER: Michael Skjei

DESIGN FIRM:

The Perlman Company,

Seattle, Washington

ART DIRECTOR/

ILLUSTRATOR/LETTERER:

Bob Perlman

DESIGNERS: Bob Perlman,

Kyle Bergersen

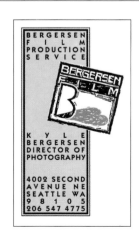

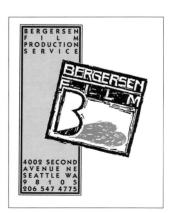

STUDIO
ONE ONE FIVE
SOUTHEAST
NINTH AVENUE
PORTLAND
OREGON
97214

TELEPHONE
503 236 9301
FACSIMILE
503 236 9301

DESIGN FIRM:

Gregory Smith Design,

Portland, Oregon

ART DIRECTOR/

DESIGNER/ILLUSTRATOR:

Gregory Smith

PRINTER:

Adprint Company

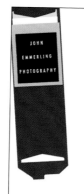

STUDIO
ONE ONE FIVE
SOUTHEAST
NINTH AVENUE
PORTLAND
OREGON
97214

John Emmerling Photography

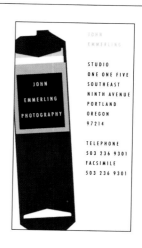

JOHN
EMMERLING

STUDIO
ONE ONE FIVE
SOUTHEAST
NINTH AVENUE
PORTLAND
OREGON
97214

TELEPHONE
503 236 9301
FACSIMILE
503 236 9301

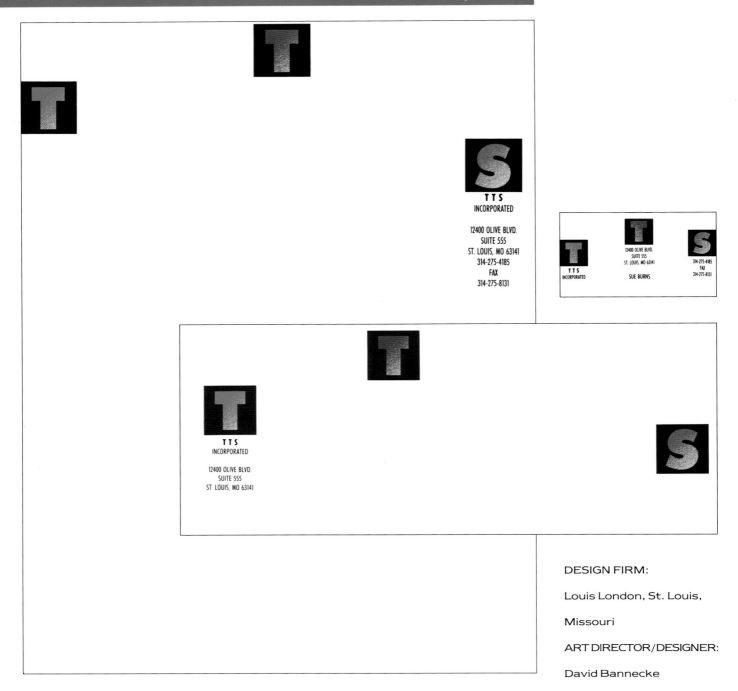

DESIGN FIRM:

Louis London, St. Louis,

Missouri

ART DIRECTOR/DESIGNER:

David Bannecke

DESIGN FIRM:

Dearwater Design,

Houston, Texas

ART DIRECTOR/DESIGNER:

Andy Dearwater

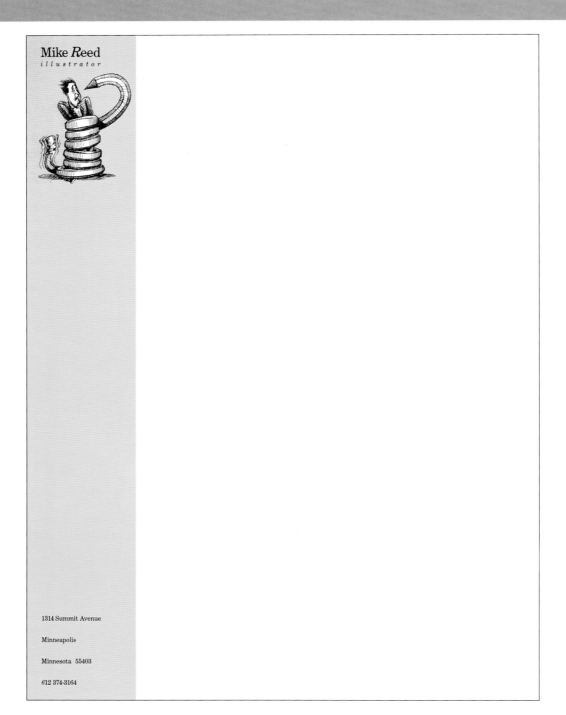

Mike *Reed*
*illustrator*

1314 Summit Avenue

Minneapolis

Minnesota 55403

612 374-3164

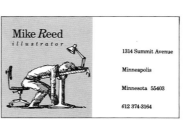

Mike *Reed*
*illustrator*

1314 Summit Avenue

Minneapolis

Minnesota 55403

612 374-3164

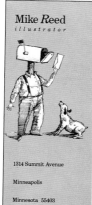

1314 Summit Avenue

Minneapolis

Minnesota 55403

DESIGN FIRM:

Tilka Design,

Minneapolis, Minnesota

ART DIRECTOR:

Jane Tilka

DESIGNER:

Cynthia Henry

ILLUSTRATOR:

Mike Reed

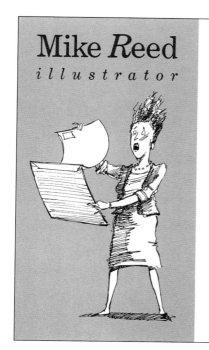

1314 Summit Avenue

Minneapolis

Minnesota 55403

612 374-3164

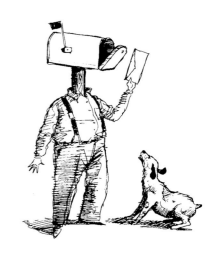

BILL
BISSELL

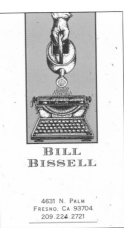

BILL
BISSELL

4631 N. PALM
FRESNO, CA 93704
209.224.2721

BILL
BISSELL

4631 N. PALM
FRESNO, CA 93704

4631 N. PALM
FRESNO, CA 93704
209.224.2721

## Bill Bissell (Copywriter)

| | |
|---|---|
| DESIGN FIRM: | ILLUSTRATOR: |
| Skip Gaynard Designs, | Skip Gaynard |
| Fresno, California | PRINTER: |
| ART DIRECTOR/DESIGNER/ | Pyramid Printing |

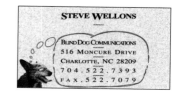

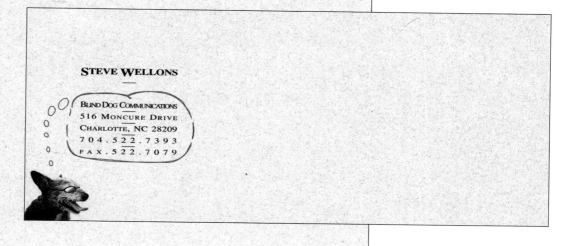

**Blind Dog Communications (Copywriter)**

DESIGN FIRM:

Steve Thomas Design,

Charlotte, North Carolina

ART DIRECTOR/DESIGNER/

ILLUSTRATOR:

Steve Thomas

PHOTOGRAPHER:

Steve Wellons

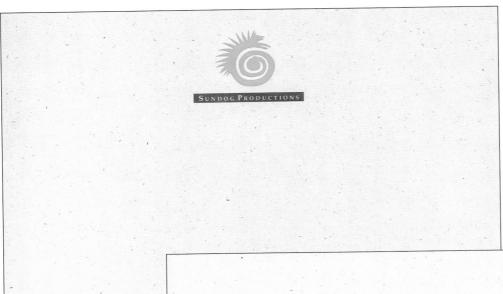

9 WALNUT AVENUE   ANDOVER, MA 01810

9 WALNUT AVENUE   ANDOVER, MA 01810   (508) 474 0905

DESIGN FIRM:

Pollard Design, East

Hartland, Connecticut

DESIGNERS:

Jeff and Adrienne Pollard

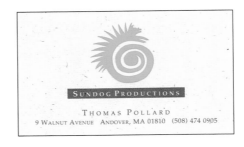

THOMAS POLLARD
9 WALNUT AVENUE   ANDOVER, MA 01810   (508) 474 0905

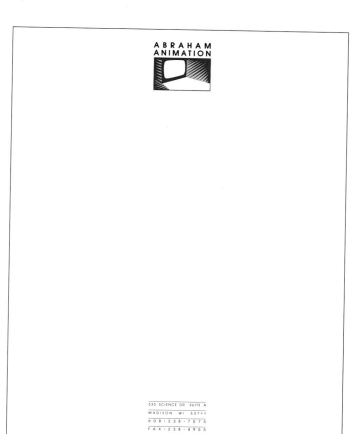

## Abraham Animation

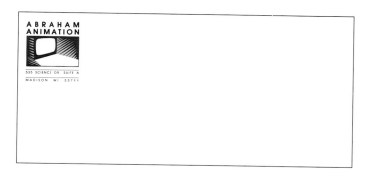

**DESIGN FIRM:**

Abraham Animation,

Madison, Wisconsin

**ART DIRECTOR:**

Richard Abraham

**DESIGNER:**

Lorna Pieterek

DESIGN FIRM:

Rick Eiber Design (RED),

Seattle, Washington

ART DIRECTOR/DESIGNER/

PHOTOGRAPHER:

Rick Eiber

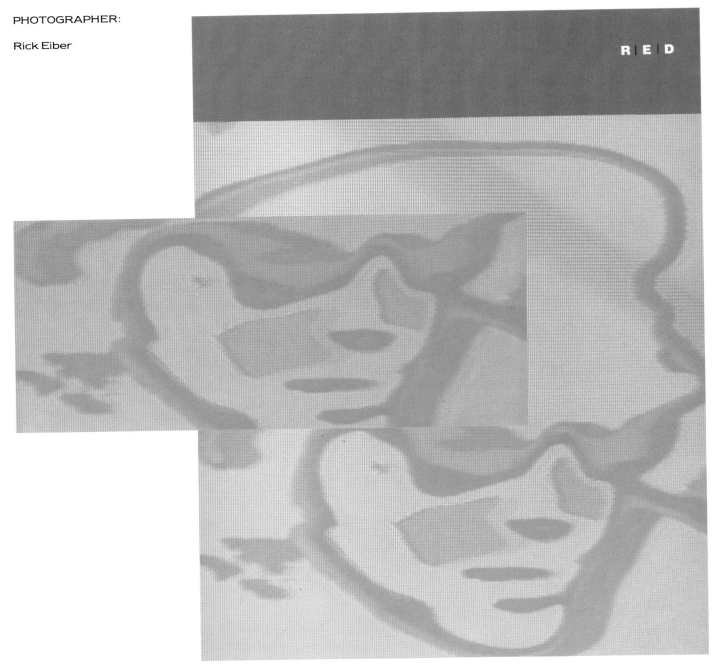

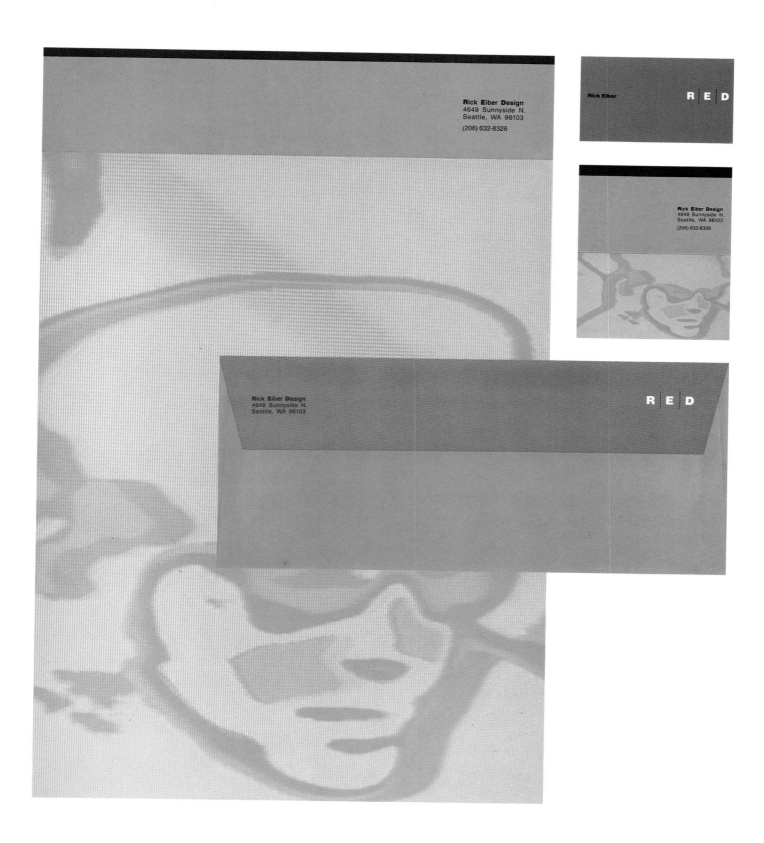

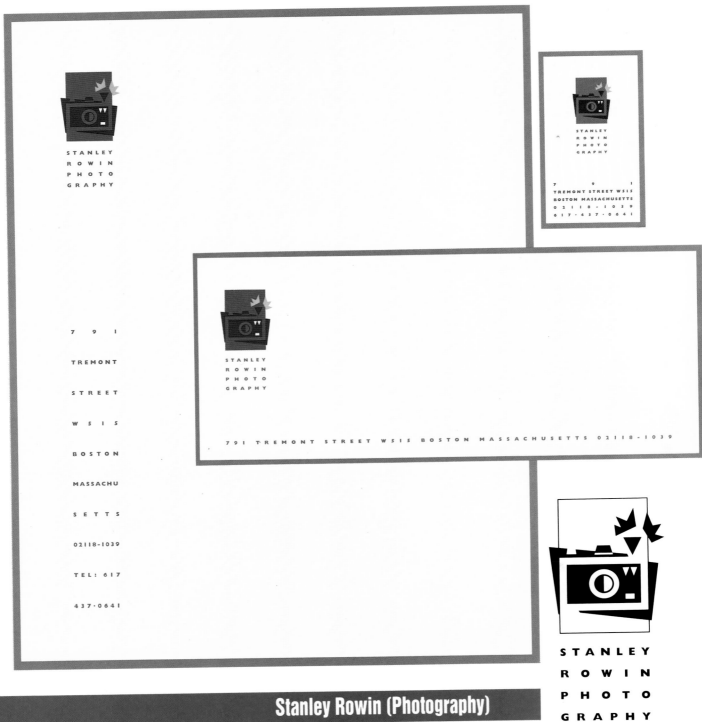

## Stanley Rowin (Photography)

STANLEY
ROWIN
PHOTO
GRAPHY

DESIGN FIRM:

Battista Design,

Boston, Massachusetts

ART DIRECTOR/DESIGNER/

ILLUSTRATOR:

John Battista

**TROPICAL
INTERIORS**

**TROPICAL
INTERIORS**

Tropical Interiors, Inc., 1616 McClain Road, P.O. Box 5005 Knoxville, TN 37928 615-689-7514

## Tropical Interiors

Matt Baker

TROPICAL INTERIORS, INC.
1616 McClain Road,
P.O. Box 5005
Knoxville, TN 37928
615-689-7514
615-567-2158 Car

DESIGN FIRM:

Easter Design Group,

Knoxville, Tennessee

DESIGNER: Robin Easter

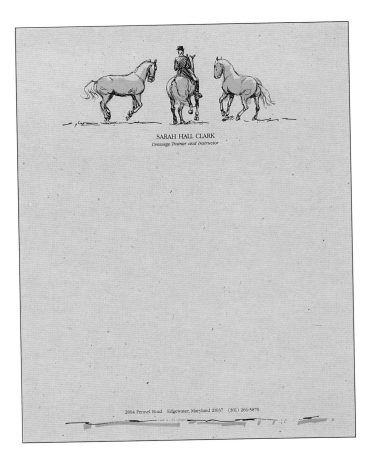

SARAH HALL CLARK
*Dressage Trainer and Instructor*

2804 Fennel Road   Edgewater, Maryland 21037   (301) 266-5870

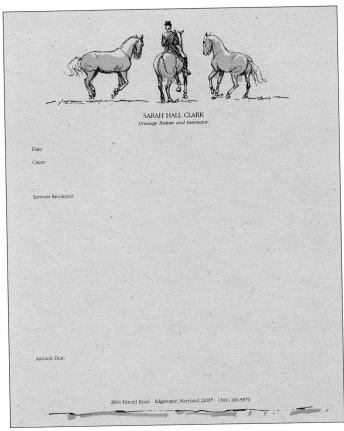

SARAH HALL CLARK
*Dressage Trainer and Instructor*

Date:

Client:

Services Rendered:

Amount Due:

2804 Fennel Road   Edgewater, Maryland 21037   (301) 266-5870

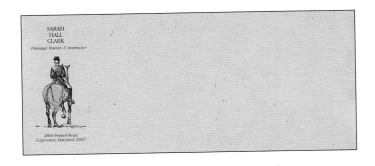

SARAH
HALL
CLARK
*Dressage Trainer & Instructor*

2804 Fennel Road
Edgewater, Maryland 21037

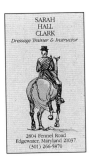

SARAH
HALL
CLARK
*Dressage Trainer & Instructor*

2804 Fennel Road
Edgewater, Maryland 21037
(301) 266-5870

## Sarah Hall Clark (Dressage Trainer/Instructor)

DESIGN FIRM:

Clark Keller, Inc.,

Annapolis, Maryland

ART DIRECTOR/DESIGNER:

Jane Keller

ILLUSTRATOR:

Frank Rawlings

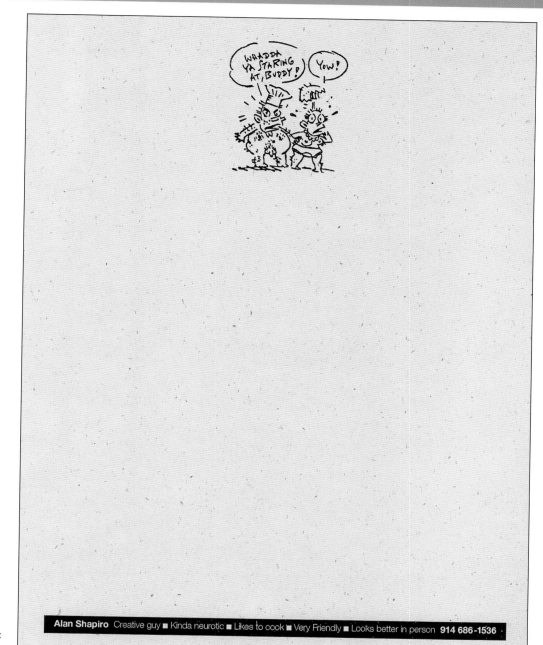

Personal letterhead.

DESIGN FIRM:

Beaumont-Bennett,

New York, New York

ART DIRECTOR/DESIGNER:

Alan Shapiro

ILLUSTRATOR:

Elwood Smith

DESIGN FIRM:

Linda Helton Design, Dallas,

Texas

ART DIRECTOR/DESIGNER:

Linda Helton

TYPOGRAPHY:

Mouseworks

PRINTERS: Artesian Press,

Monarch Press

*Linda Helton Design/Illustration  11480 Audelia #246  Dallas, Texas 75243  214/553-0298  Fax 214/553-9187*

DESIGN FIRM:

Sue Crolick Advertising &

Design, Minneapolis,

Minnesota

ART DIRECTOR/DESIGNER:

Sue Crolick

COPYWRITER:

Joan Ostrin

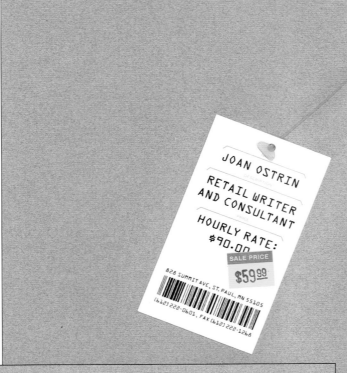

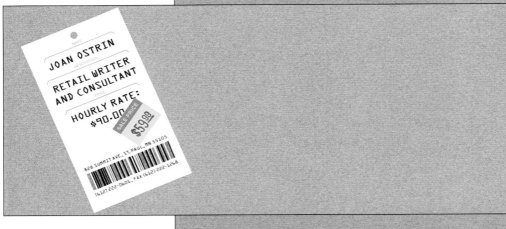

## Joan Ostrin (Retail Writer & Consultant)

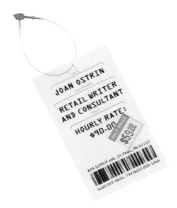

DESIGN FIRM:

MAH Design,

Houston, Texas

ART DIRECTORS/

DESIGNERS/ILLUSTRATORS:

Mary Anne Heckman,

Jack Slattery

**J** **Jean Sheives**
**E** Photographer
**A** 1243 West 34th Street
**N** Houston, Texas
**V** 77018
**E** Commercial, Studio
**S** And Location Photography

**J** **Jean Sheives**
**E** Photographer
**A** Office 713/880-5824
**N** Studio 713/524-3888
**S** 1243 West 34th Street
**H** Houston, Texas
**E** 77018
**I** Commercial
**V** Studio
**E** And Location
**S** Photography

## Jean Sheives Photography

**J** **Jean Sheives**
**E** Photographer
**A** Office 713/880-5824
**N** Studio 713/524-3888
**S** 1243 West 30th St.
**H** Houston, Texas
**E** 77018
**I** Commercial
**V** Studio
**E** And Location
**S** Photography

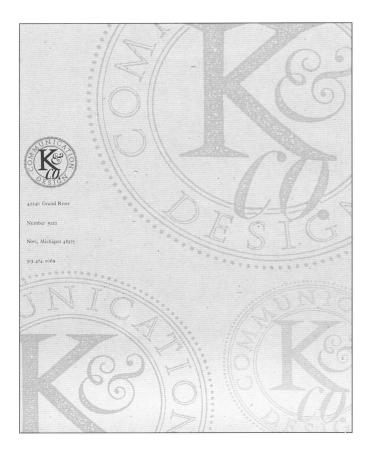

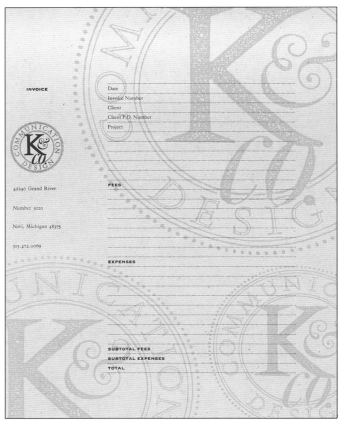

INVOICE

Date

Invoice Number

Client

Client P.O. Number

Project

FEES

EXPENSES

SUBTOTAL FEES

SUBTOTAL EXPENSES

TOTAL

42240 Grand River

Number 5020

Novi, Michigan 48375

313.474.0069

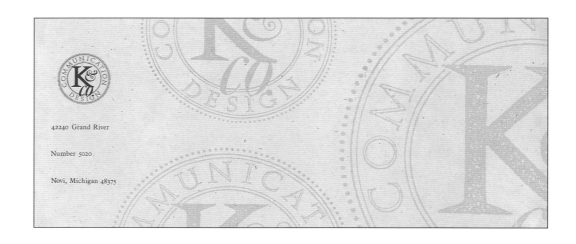

42240 Grand River

Number 5020

Novi, Michigan 48375

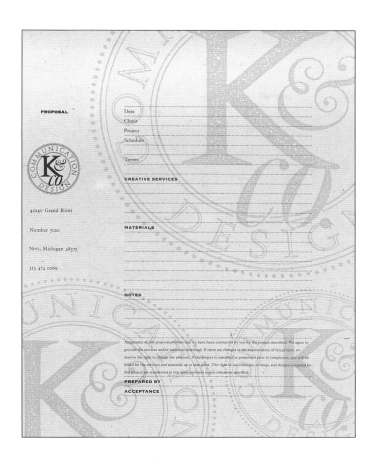

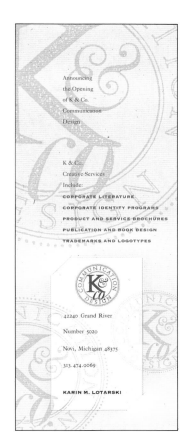

## K & Co. Communication Design

DESIGN FIRM:

K & Co. Communication

Design, Farmington Hills,

Michigan

ART DIRECTOR/DESIGNER:

Karin M. Lotarski

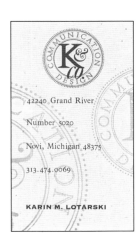

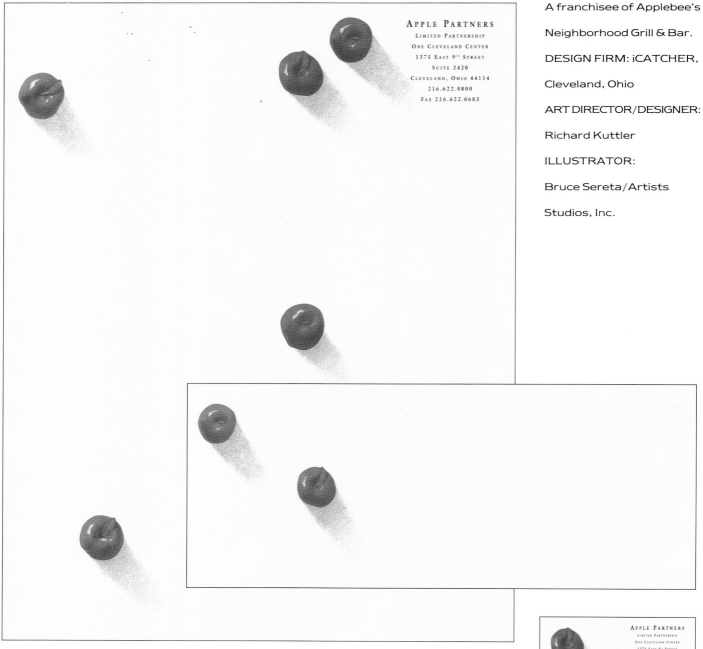

**APPLE PARTNERS**
LIMITED PARTNERSHIP
ONE CLEVELAND CENTER
1375 EAST 9TH STREET
SUITE 2420
CLEVELAND, OHIO 44114
216.622.0800
FAX 216.622.0603

A franchisee of Applebee's

Neighborhood Grill & Bar.

DESIGN FIRM: iCATCHER,

Cleveland, Ohio

ART DIRECTOR/DESIGNER:

Richard Kuttler

ILLUSTRATOR:

Bruce Sereta/Artists

Studios, Inc.

**APPLE PARTNERS**
LIMITED PARTNERSHIP
ONE CLEVELAND CENTER
1375 EAST 9TH STREET
SUITE 2420
CLEVELAND, OHIO 44114
216.622.0800
FAX 216.622.0603

THOMAS K. DENOMME
GENERAL PARTNER

**APPLE PARTNERS**
LIMITED PARTNERSHIP
ONE CLEVELAND CENTER
1375 EAST 9TH STREET
SUITE 2420
CLEVELAND, OHIO 44114

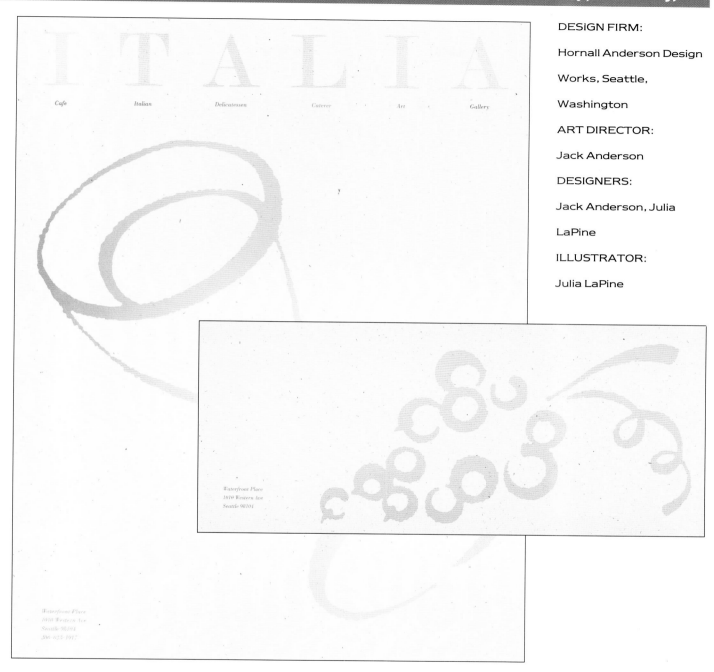

DESIGN FIRM:

Hornall Anderson Design

Works, Seattle,

Washington

ART DIRECTOR:

Jack Anderson

DESIGNERS:

Jack Anderson, Julia

LaPine

ILLUSTRATOR:

Julia LaPine

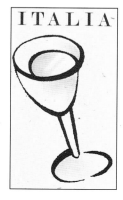

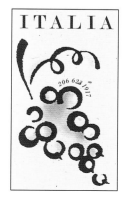

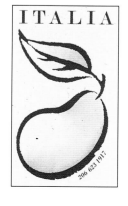

◕◕  R O S A N N E  **P E R C I V A L L E**   521 W 26 ST   8TH FLOOR   NYC, NY 10001

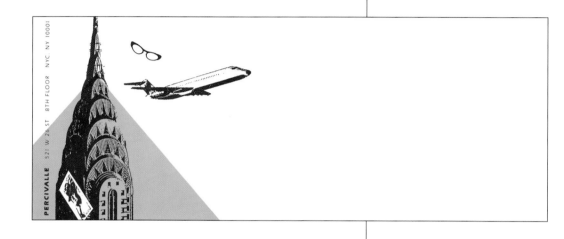

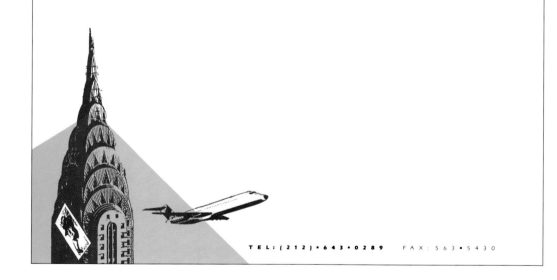

TEL: (212) ▪ 643 ▪ 0289    FAX: 5 6 3 ▪ 5 4 3 0

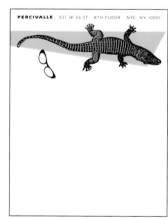

# J O B  O R D E R  F O R M

R O S A N N E
**P E R C I V A L L E**
I L L U S T R A T E S
4 3 0  W  1 4  S T  R O O M  4 1 3
N Y C ,  N Y  1 0 0 1 4
**T E L : ( 2 1 2 ) ▪ 6 3 3 ▪ 2 4 8 0**
F A X : ( 2 1 2 ) ▪ 6 7 5 ▪ 3 5 5 8
**T A X  I D # : 0 9 4 ▪ 5 2 ▪ 4 1 4 7**

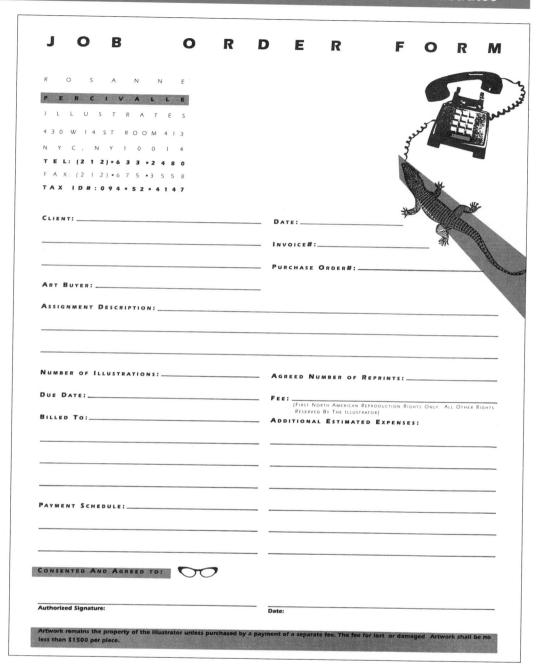

CLIENT: _____

_____

_____

ART BUYER: _____

ASSIGNMENT DESCRIPTION: _____

_____

_____

_____

NUMBER OF ILLUSTRATIONS: _____

DUE DATE: _____

BILLED TO: _____

_____

_____

_____

PAYMENT SCHEDULE: _____

_____

_____

DATE: _____

INVOICE#: _____

PURCHASE ORDER#: _____

AGREED NUMBER OF REPRINTS: _____

FEE: _____
(FIRST NORTH AMERICAN REPRODUCTION RIGHTS ONLY. ALL OTHER RIGHTS RESERVED BY THE ILLUSTRATOR)

ADDITIONAL ESTIMATED EXPENSES:

_____

_____

_____

_____

_____

_____

CONSENTED AND AGREED TO:

Authorized Signature: _____          Date: _____

Artwork remains the property of the Illustrator unless purchased by a payment of a separate fee. The fee for lost or damaged Artwork shall be no less than $1500 per piece.

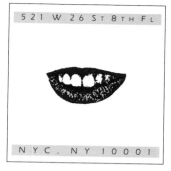

5 2 1  W  2 6  S T  8 T H  F L

N Y C ,  N Y  1 0 0 0 1

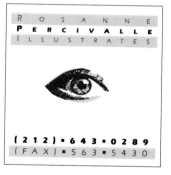

R O S A N N E
**P E R C I V A L L E**
I L L U S T R A T E S

**( 2 1 2 ) ▪ 6 4 3 ▪ 0 2 8 9**
( F A X ) ▪ 5 6 3 ▪ 5 4 3 0

DESIGN FIRM:

Roseanne Percivalle

Illustrates, New York,

New York

ART DIRECTOR/DESIGNER/

ILLUSTRATOR:

Roseanne Percivalle

# Justin Cohen, M.D. (Pediatriatric Opthamologist/Surgeon)

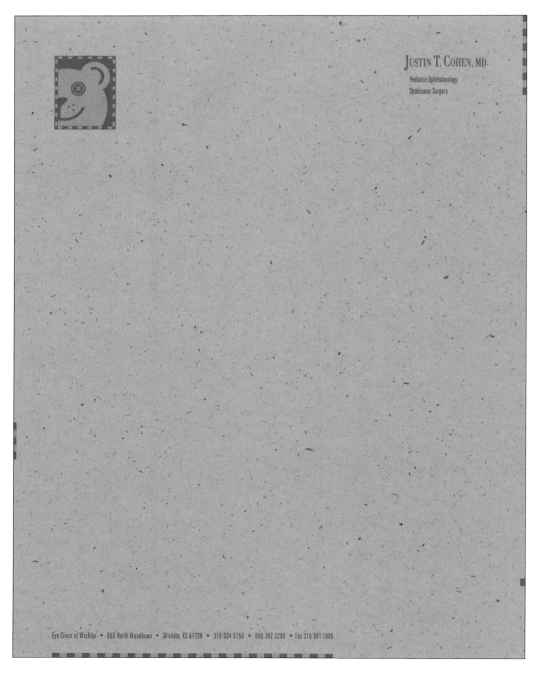

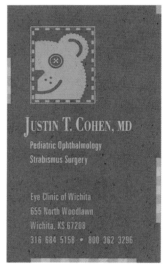

DESIGN FIRM:

Gardner + Greteman,

Wichita, Kansas

CREATIVE DIRECTORS/

ART DIRECTORS/DESIGNERS:

Susan Mikulecky, Bill

Gardner, Sonia Greteman

DESIGN FIRM:

Helen Strang Graphic

Design & Illustration,

Nevada City, California

ART DIRECTOR/DESIGNER/

ILLUSTRATOR:

Helen Strang

**JAMES H. JONES, JR.**
**D.D.S., M.S.**

*Practice Limited To Periodontics*
*A member of the California*
*Society of Periodontists &*
*California Dental Association*

*316 S. Auburn Street*
*Grass Valley, CA 95945*
*916 / 273•3312*

**JAMES H. JONES, JR.**
**D.D.S., M.S.**

*316 S. Auburn Street*
*Grass Valley, CA 95945*

**JAMES H. JONES, JR.**
**D.D.S., M.S.**
*Practice Limited To Periodontics*

*316 S. Auburn Street*
*Grass Valley, CA 95945*
*916 / 273•3312*

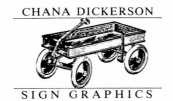

CHANA DICKERSON
SIGN GRAPHICS

DESIGN FIRM:

Chana Dickerson Sign

Graphics, La Cañada,

California

ART DIRECTOR/DESIGNER:

Chana Dickerson

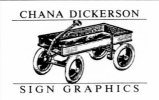

CHANA DICKERSON
SIGN GRAPHICS

4374 CHEVY CHASE DRIVE   LA CAÑADA, CALIFORNIA   91011        (818) 952-3208

4374 CHEVY CHASE DRIVE   LA CAÑADA, CALIFORNIA   91011        (818) 952-3208

## Chana Dickerson Sign Graphics

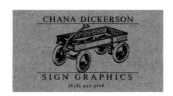

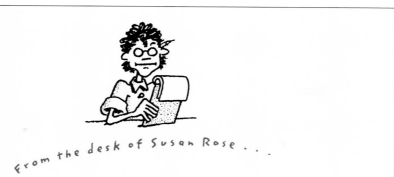

From the desk of Susan Rose . . .

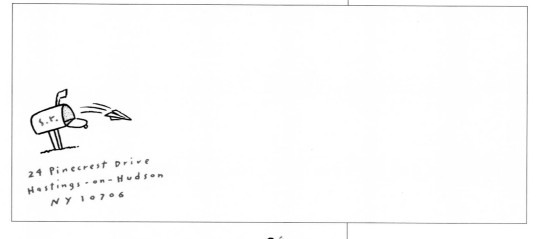

24 Pinecrest Drive
Hastings-on-Hudson
NY 10706

24 Pinecrest Drive
Hastings-on-Hudson
NY 10706

914 478 7164

Personal stationery.

DESIGN FIRM:

Susan Rose Design,

New York, New York

DESIGNER/ILLUSTRATOR:

Susan Rose

**Susan Rose (Designer/Illustrator)**

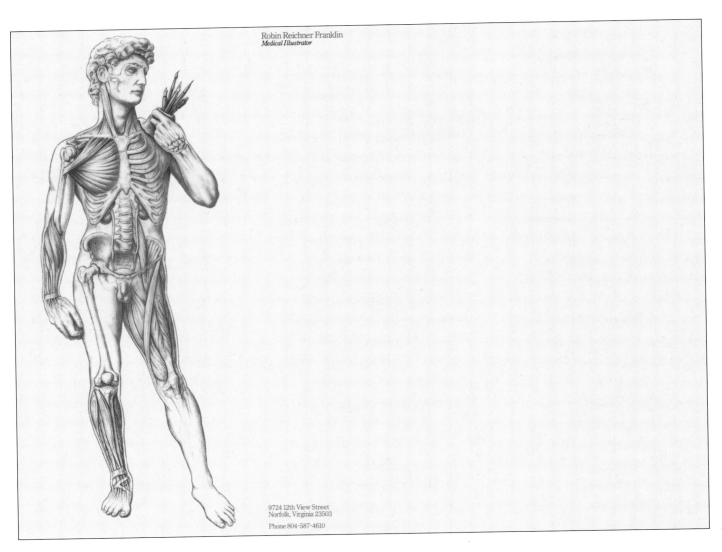

Robin Reichner Franklin
*Medical Illustrator*

9724 12th View Street
Norfolk, Virginia 23503

Phone 804·587·4610

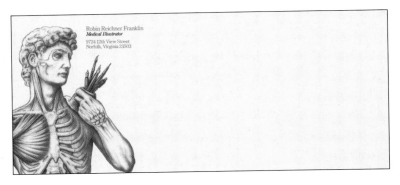

Robin Reichner Franklin
*Medical Illustrator*
9724 12th View Street
Norfolk, Virginia 23503

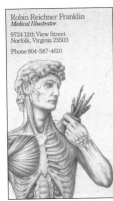

Robin Reichner Franklin
*Medical Illustrator*

9724 12th View Street
Norfolk, Virginia 23503

Phone 804·587·4610

DESIGN FIRM:

Harrisberger Creative,

Virginia Beach, Virginia

ART DIRECTOR/DESIGNER:

Lynn Harrisberger

ILLUSTRATOR:

Robin Reichner-Franklin

**Robin Reichner-Franklin (Medical Illustrator)**

DESIGN FIRM:

David Warren Design,

Denver, Colorado

ART DIRECTOR/DESIGNER:

David Warren

ILLUSTRATOR:

Diego Ruiz

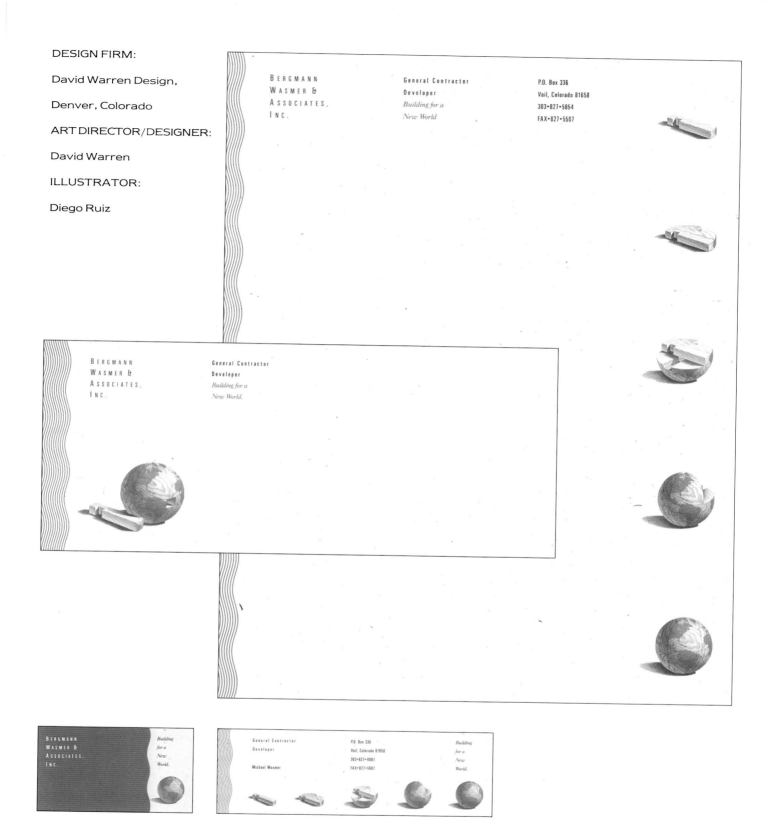

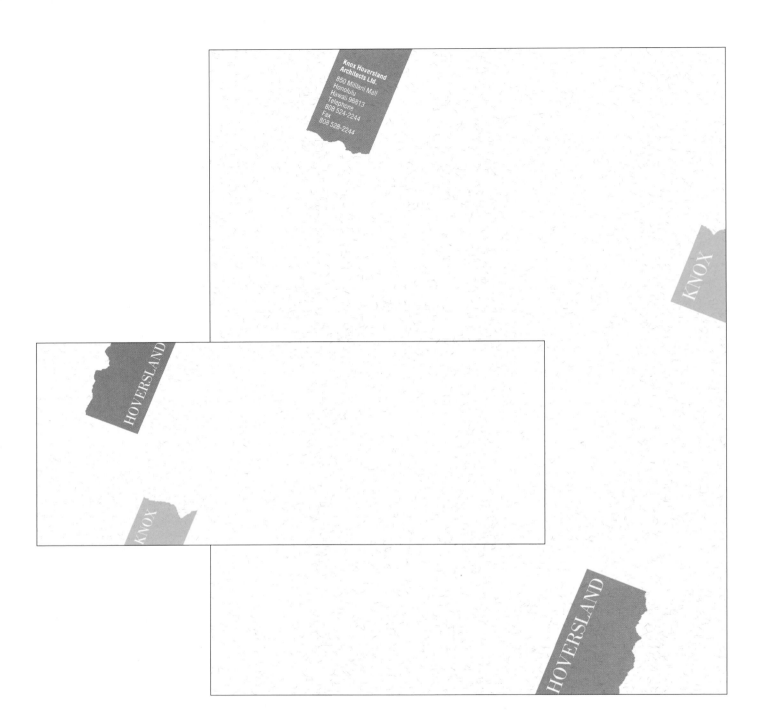

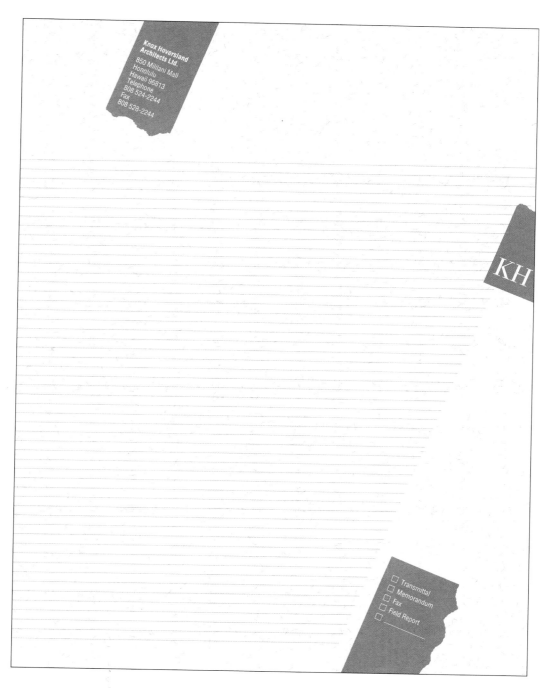

DESIGN FIRM:

Linschoten & Associates,

Honolulu, Hawaii

ART DIRECTOR/DESIGNER:

Bud Linschoten

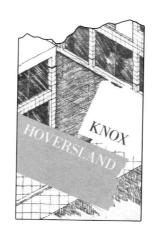

Knox Hoversland Architects Ltd.

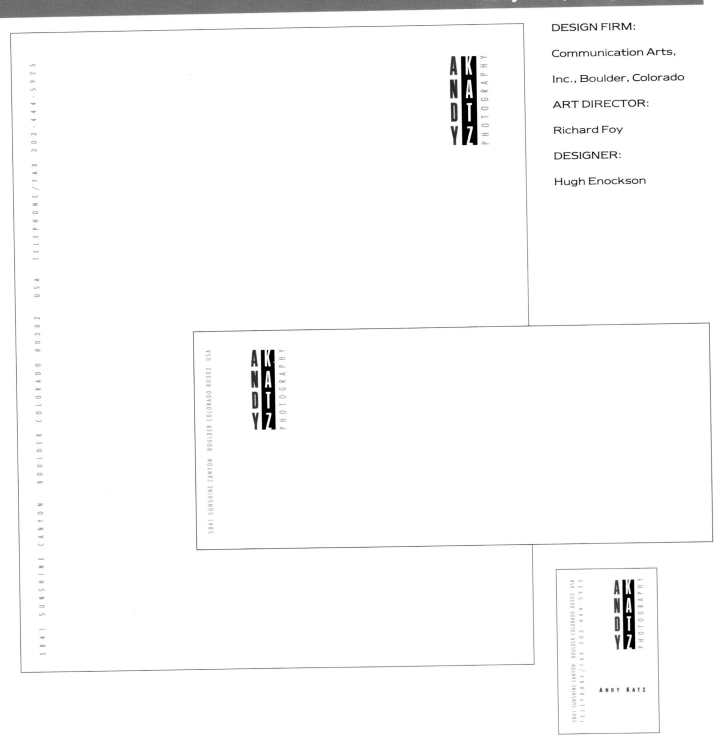

DESIGN FIRM:

Communication Arts,

Inc., Boulder, Colorado

ART DIRECTOR:

Richard Foy

DESIGNER:

Hugh Enockson

DESIGN FIRM:

Pedersen & Gesk, Inc.,

Minneapolis, Minnesota

ART DIRECTOR/DESIGNER:

Mitchell Lindgren

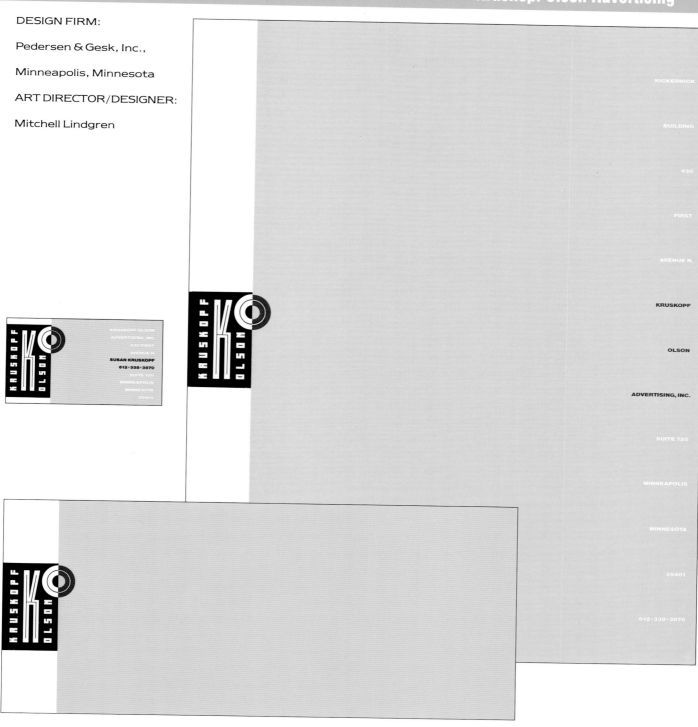

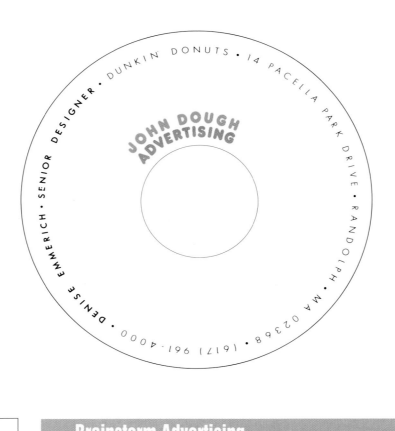

DESIGN FIRM:

John Dough Advertising,

Randolph, Massachusetts

ART DIRECTOR/DESIGNER:

Denise Emmerich

## Brainstorm Advertising

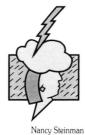

Nancy Steinman
Creative Director

◆ Brainstorm Advertising

23205 Sesame St.
Torrance, CA 90502
310.518.9605

DESIGN FIRM:

Brainstorm Advertising,

Torrance , California

ART DIRECTOR/DESIGNER/

ILLUSTRATOR:

Nancy Steinman

Aaron Buckman is a

freelance writer.

DESIGN FIRM:

Kym Abrams Design,

Chicago, Illinois

ART DIRECTOR:

Kym Abrams

DESIGNER: Charlyne Fabi

## Buckman Ink, Inc.

Buchman Ink, inc.
28906 North Wade Avenue
Wauconda, Illinois 60084
708.526.6149 Phone
708.526.6150 Fax

Aaron Buchman
President

## Ann Haskel (Women's Weight Trainer)

DESIGN FIRM:

Michael Stanard, Inc.,

Evanston, Illinois

ART DIRECTOR:

Michael Stanard

DESIGNER:

Lisa Fingerhut

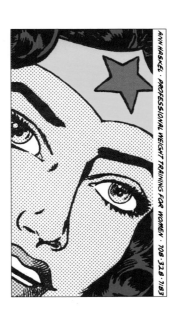

ANN HASKEL · PROFESSIONAL WEIGHT TRAINING FOR WOMEN · 708 · 328 · 7183

DESIGN FIRM:

Chameleon Design,

Phoenix, Arizona

ART DIRECTOR/DESIGNER:

Cindy Jennings

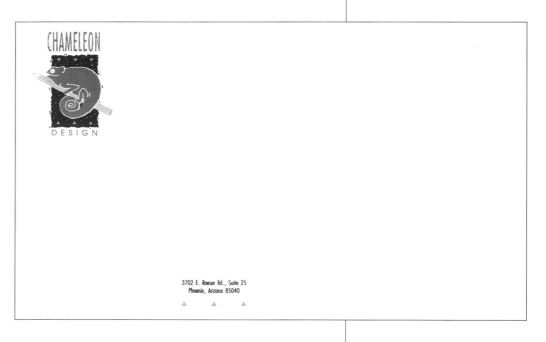

3702 E. Roeser Rd., Suite 25
Phoenix, Arizona 85040

(602) 437-3371   Fax. 437-5750
3702 E. Roeser Rd., Suite 25
Phoenix, Arizona 85040

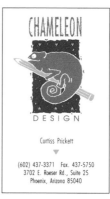

Curtiss Prickett

(602) 437-3371   Fax. 437-5750
3702 E. Roeser Rd., Suite 25
Phoenix, Arizona 85040

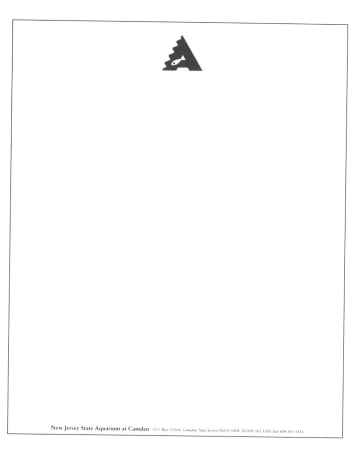

New Jersey State Aquarium at Camden  P.O. Box 95004, Camden, New Jersey 08101-5004 Tel 609.365.3300 Fax 609.365.3311

## New Jersey State Aquarium

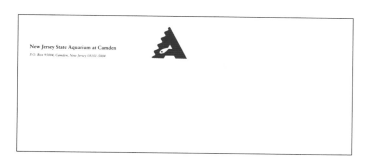

New Jersey State Aquarium at Camden
P.O. Box 95004, Camden, New Jersey 08101-5004

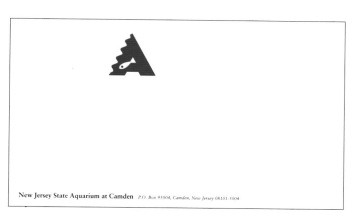

New Jersey State Aquarium at Camden  P.O. Box 95004, Camden, New Jersey 08101-5004

New Jersey State Aquarium at Camden

Randy M. Mickley, M.Aq.
Aquarist

P.O. Box 95004, Camden, New Jersey 08101-5004 Tel 609.365.3300 Fax 609.365.3311

DESIGN FIRM:

Cook and Shanosky

Associates, Inc.,

Princeton, New Jersey

ART DIRECTORS:

Roger Cook, Don

Shanosky

DESIGNER:

Douglas Baszczuk

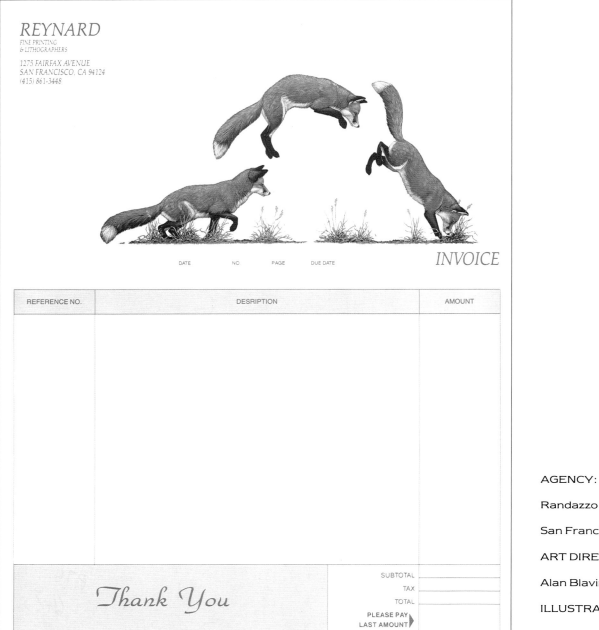

REYNARD
FINE PRINTING
& LITHOGRAPHERS

1275 FAIRFAX AVENUE
SAN FRANCISCO, CA 94124
(415) 861-3448

DATE          NO          PAGE          DUE DATE

*INVOICE*

| REFERENCE NO. | DESRIPTION | AMOUNT |
|---|---|---|
| | | |

*Thank You*

SUBTOTAL
TAX
TOTAL
PLEASE PAY
LAST AMOUNT

AGENCY:

Randazzo & Blavins, Inc.,

San Francisco, California

ART DIRECTOR:

Alan Blavins

ILLUSTRATOR: Carl Bule

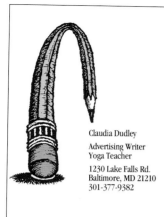

Claudia Dudley

Advertising Writer
Yoga Teacher

1230 Lake Falls Rd.
Baltimore, MD 21210
301-377-9382

Claudia Dudley
1230 Lake Falls Rd.
Baltimore, MD 21210

DESIGN FIRM:

Butler Art Direction &

Design, Edgewater,

Maryland

ART DIRECTOR/DESIGNER/

ILLUSTRATOR:

Belinda C. Butler

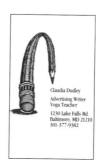

Claudia Dudley

Advertising Writer
Yoga Teacher

1230 Lake Falls Rd.
Baltimore, MD 21210
301-377-9382

Specializes in public relations
for the home furnishings
industry.

DESIGN FIRM:

Mervil Paylor Design,

Charlotte, North Carolina

ART DIRECTOR/DESIGNER/

ILLUSTRATOR:

Mervil M. Paylor

**Johnson Powell**

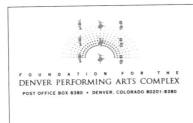

DESIGN FIRM:

DeOlivera Creative, Inc.,

Denver, Colorado

ART DIRECTOR:

Richard A. DeOlivera

DESIGNERS:

Jim Walden,

Richard A. DeOlivera

Committee:
Nancy C. Allen
Anne Brent
Arden Brock
Katie Cullen
Andrea Ferguson
Mary Gilbreath
Mimi Del Grande
Linda Gray
Gracie Hamilton
Kristina Hanson
Denise Hazen
Sarita Armstrong Hixon
Christina Girard Hudson
Louise Jamail
Karen Kelsey

Barbara King
Patricia J. Lasher
Martha Long
Jean May
Kathy Cullen McCord
Jenny Long Murphy
Jeri Nordbrock
Martha Farish Oti
Maricela Pappas
Kim Parks
Alice Randall
Candice Schiller
Darla Spears
Karen Susman
Gwendolyn Guinn Taylor
Joni Zavitsanos

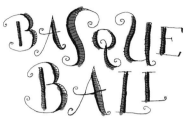

CONTEMPORARY ARTS MUSEUM
1992 Ball Committee

Co-chairmen
Blanca Uzeta O'Leary ✛ Wick Nalle Rowland

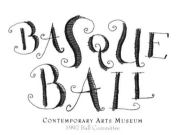

CONTEMPORARY ARTS MUSEUM
1992 Ball Committee

5216 Montrose Blvd. ✛ Houston, Texas 77006-6598

5216 Montrose Blvd. ✛ Houston, **Texas** 77006-6598 ✛ 713-526-0773

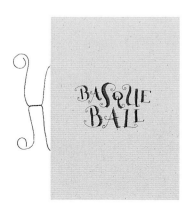

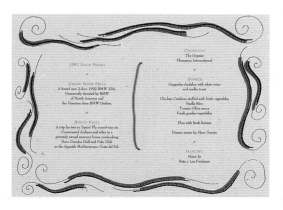

Stationery for special

fundraising event.

DESIGN FIRM:

Fuller Dyal & Stamper,

Austin, Texas

ART DIRECTOR/

ILLUSTRATOR:

Herman Dyal

DESIGNERS:

Herman Dyal,

Susan McIntyre

DESIGN FIRM:

Th'ng Design, Baton

Rouge, Louisiana

ART DIRECTORS/DESIGNERS:

Charlie and Connie Th'ng

ILLUSTRATOR:

Charlie Th'ng

PRINTER:

Moran Printing, Inc.

**Th'ng Design**

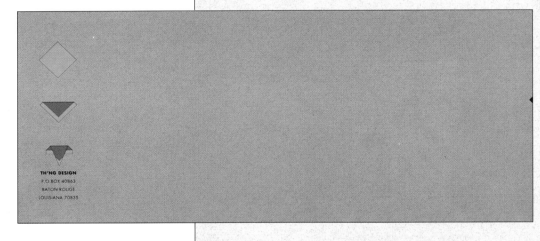

TH'NG DESIGN

TH'NG DESIGN
P.O. BOX 40863
BATON ROUGE
LOUISIANA 70835

P.O. BOX 40863
BATON ROUGE
LOUISIANA 70835
TEL: 504-273-3336

TH'NG DESIGN

CHARLIE TH'NG

P.O. BOX 40863
BATON ROUGE
LOUISIANA 70835
TEL: 504-924-8464
FAX: 504-927-8874

TH'NG (t'ung) pron. tongue

DESIGN FIRM:

Siebert Design, Cincinnati,

Ohio

ART DIRECTORS/DESIGNERS:

Lori Siebert, Lisa Ballard

ILLUSTRATOR: Lisa Ballard

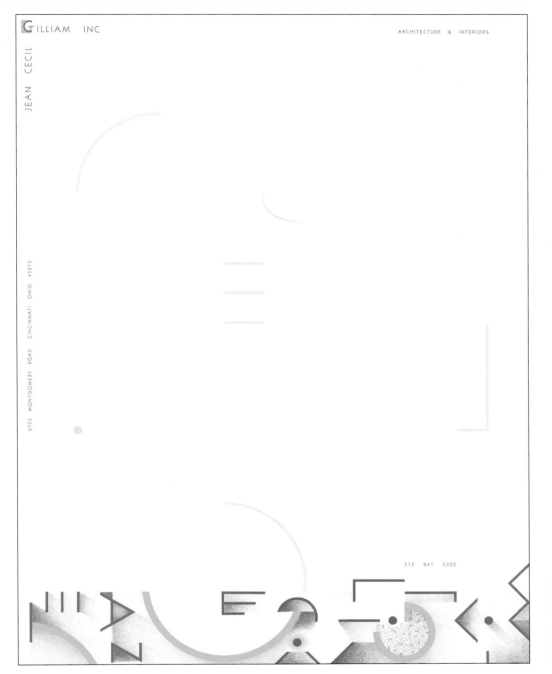

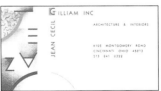

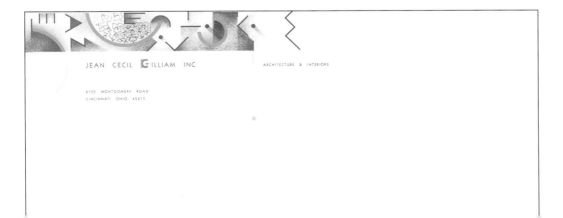

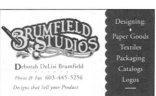

Designing:
♦
Paper Goods
Textiles
Packaging
Catalogs
Logos
___

Deborah DeLisi Brumfield

Phone & Fax 603-445-5256

Designs that Sell your Product

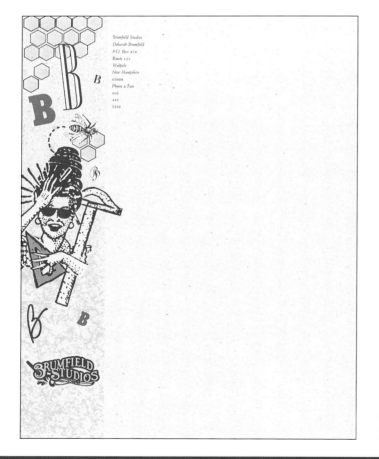

Brumfield Studios
Deborah Brumfield
P.O. Box 879
Route 123
Walpole
New Hampshire
03608
Phone & Fax
603
445
5256

Brumfield Studios
Deborah Brumfield
P.O. Box 879
Route 123
Walpole
New Hampshire
03608
Phone & Fax
603
445
5256

DESIGN FIRM:

Brumfield Studios, Walpole,

New Hampshire

ART DIRECTOR/DESIGNER/

ILLUSTRATOR:

Deborah DeLisi Brumfield

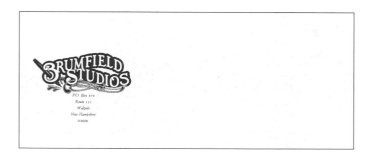

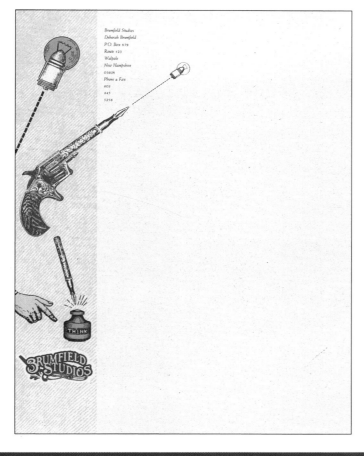

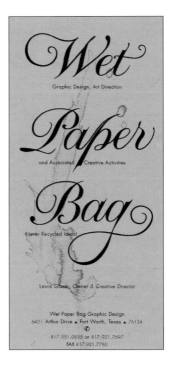

## Wet Paper Bag Graphic Design

DESIGN FIRM:

Wet Paper Bag Graphic

Design, Fort Worth , Texas

ART DIRECTOR/DESIGNER/

LETTERER: Lewis Glaser

Stationery for Brew Pub

Poets Society.

DESIGN FIRM:

Dillard Patterson,

Charlotte, North Carolina

CREATIVE DIRECTOR:

Jack Dillard

DESIGNER:

Drew Patterson

PRINTER:

Mercury Printing

Brew Pub Poets Society

1301 East Boulevard
Charlotte, NC 28203

Dilworth Brewing Company
1301 East Boulevard
Charlotte, NC 28203
704-377-BREW

DESIGN FIRM:

O'Keefe Marketing,

Richmond, Virginia

ART DIRECTOR:

Kelly O'Keefe

DESIGNER: David King

ILLUSTRATOR:

Jack Williams

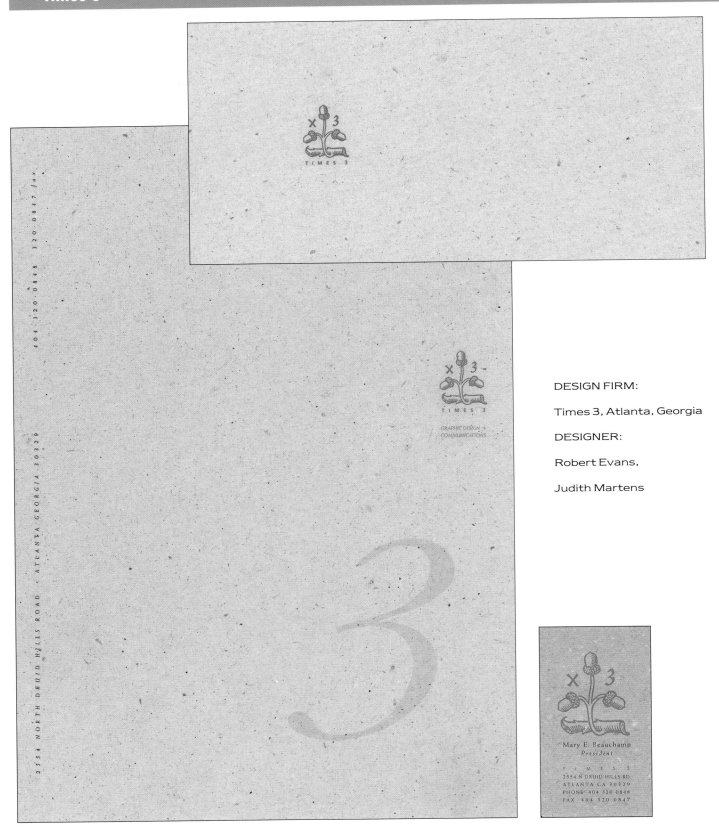

DESIGN FIRM:

Times 3, Atlanta, Georgia

DESIGNER:

Robert Evans,

Judith Martens

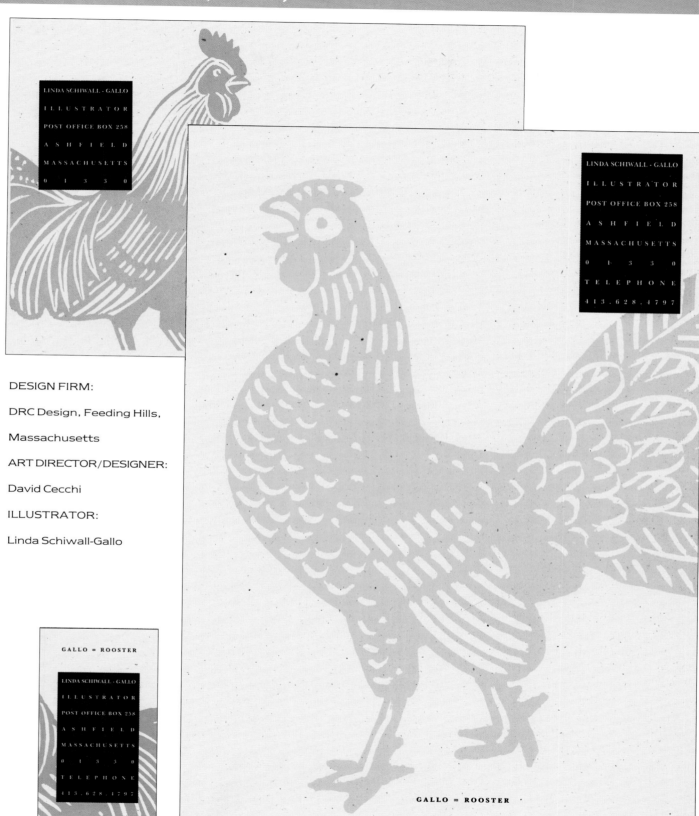

DESIGN FIRM:

DRC Design, Feeding Hills,

Massachusetts

ART DIRECTOR/DESIGNER:

David Cecchi

ILLUSTRATOR:

Linda Schiwall-Gallo

GALLO = ROOSTER

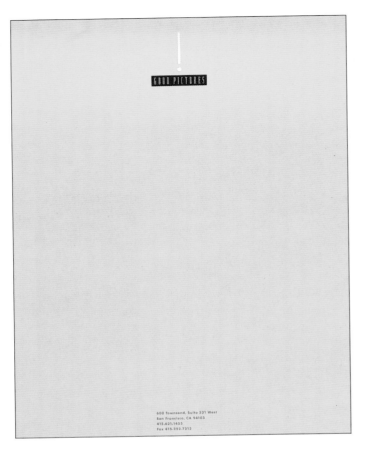

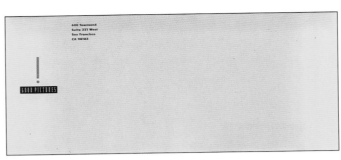

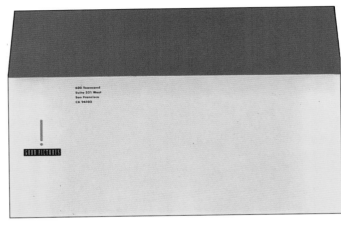

## Good Pictures (Video Production)

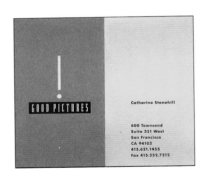

DESIGN FIRM:

Morla Design,

San Francisco, California

ART DIRECTOR:

Jennifer Morla

DESIGNERS:

Jennifer Morla,

Sharrie Brooks

DESIGN FIRM:

Stuart Rowley Design,

Santa Monica, California

ART DIRECTOR/DESIGNER:

Stuart Rowley

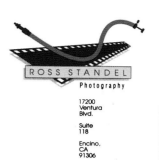

ROSS STANDEL
Photography

17200
Ventura
Blvd.

Suite
118

Encino,
CA
91306

818
907
0107

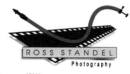

ROSS STANDEL
Photography

17200
Ventura
Blvd.

Suite
118

Encino,
CA
91306

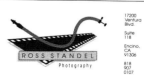

17200
Ventura
Blvd.

Suite
118

Encino,
CA
91306

818
907
0107

ROSS STANDEL
Photography

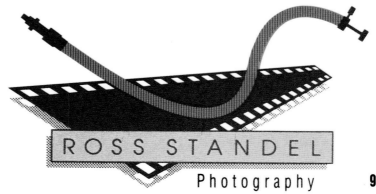

ROSS STANDEL
Photography

Personal stationery for a real estate developer.

DESIGN FIRM:

Debra Nichols Design,

San Francisco, California

ART DIRECTOR:

Debra Nichols

DESIGNERS:

Debra Nichols,

Kelan Smith

Support organization for
families who have recently
lost loved ones.

DESIGN FIRM:

Pennebaker Design,
Houston, Texas

ART DIRECTOR/DESIGNER/
ILLUSTRATOR:

David Lerch

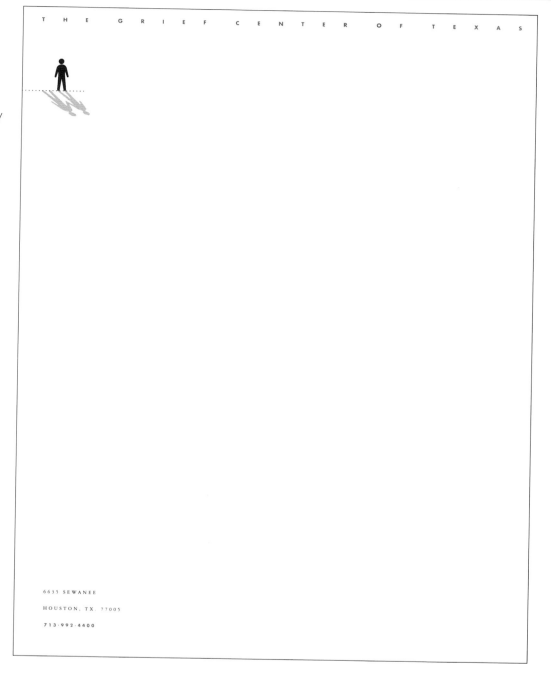

THE GRIEF CENTER OF TEXAS

6635 SEWANEE

HOUSTON, TX. 77005

713-992-4400

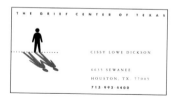

THE GRIEF CENTER OF TEXAS

CISSY LOWE DICKSON

6635 SEWANEE
HOUSTON, TX. 77005
713-992-4400

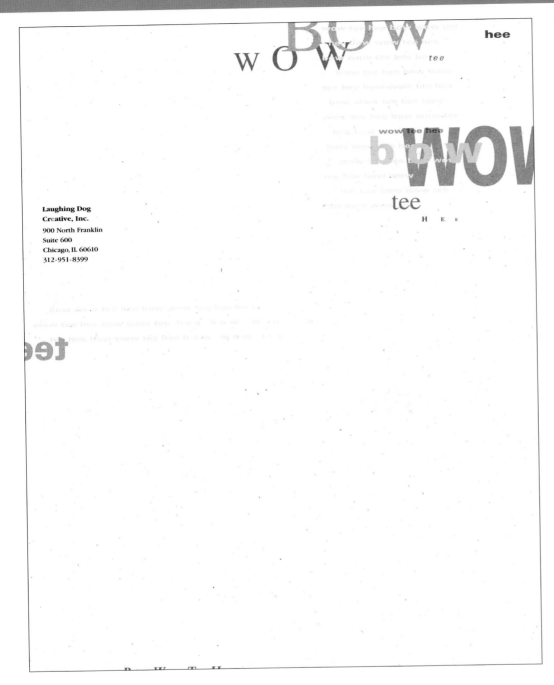

**Laughing Dog
Creative, Inc.**

900 North Franklin
Suite 600
Chicago, IL 60610
312-951-8399

**Laughing Dog
Creative, Inc.**
900 North Franklin
Suite 600
Chicago, IL 60610
312-951-8399

R Jamie Apel
Dogmatic

**Laughing Dog
Creative, Inc.**
900 North Franklin
Suite 600
Chicago, IL 60610
312-951-8399

Frank EE Grubich
Top Dog

**Laughing Dog
Creative, Inc.**
900 North Franklin
Suite 600
Chicago, IL 60610
312-951-8399

Hilary Austin
Retriever

**Laughing Dog
Creative, Inc.**
900 North Franklin
Suite 600
Chicago, IL 60610
312-951-8399

Joy Panos
Stray

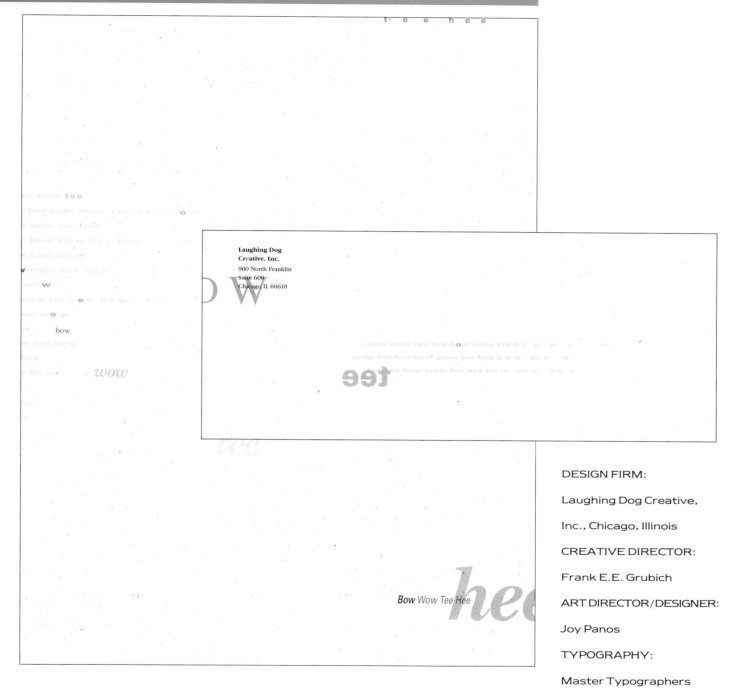

Laughing Dog
Creative, Inc.
900 North Franklin
Suite 600
Chicago, IL 60610

Bow Wow Tee Hee

DESIGN FIRM:

Laughing Dog Creative,

Inc., Chicago, Illinois

CREATIVE DIRECTOR:

Frank E.E. Grubich

ART DIRECTOR/DESIGNER:

Joy Panos

TYPOGRAPHY:

Master Typographers

SEPARATOR & PRINTER:

Ultragraphics Litho, Inc.

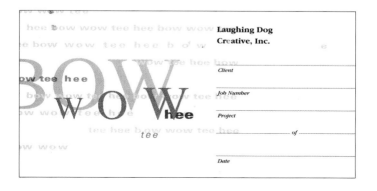

Laughing Dog
Creative, Inc.

Client

Job Number

Project

of

Date

**97**

DESIGN FIRM:

Ideal Design, Crestwood,

Kentucky

DESIGNER/ILLUSTRATOR:

Tommie Ratliff

Vietnam Widows Research Project    P.O. Box 332    Prospect, KY    40059-0332

Vietnam Widows Research Project
P.O. Box 332
Prospect, KY 40059-0332
Peggy L. Borsay, Ph.D.
(502) 561-4686  (502) 228-4005

**Vietnam Widows Research Foundation**

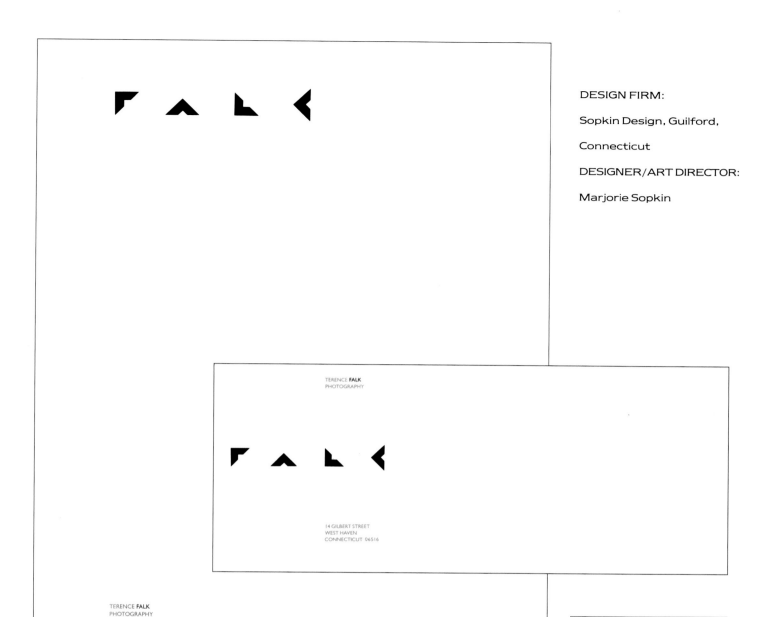

DESIGN FIRM:

Sopkin Design, Guilford,

Connecticut

DESIGNER/ART DIRECTOR:

Marjorie Sopkin

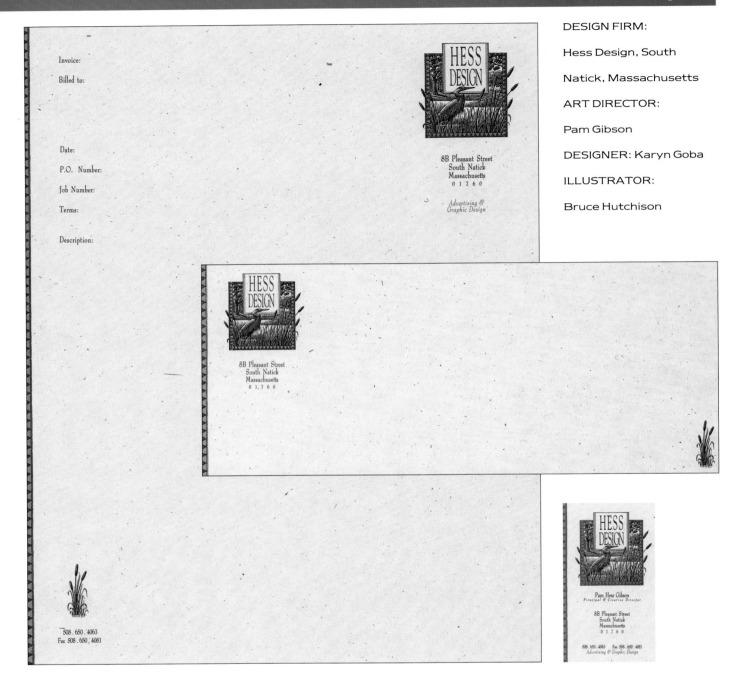

DESIGN FIRM:

Hess Design, South

Natick, Massachusetts

ART DIRECTOR:

Pam Gibson

DESIGNER: Karyn Goba

ILLUSTRATOR:

Bruce Hutchison

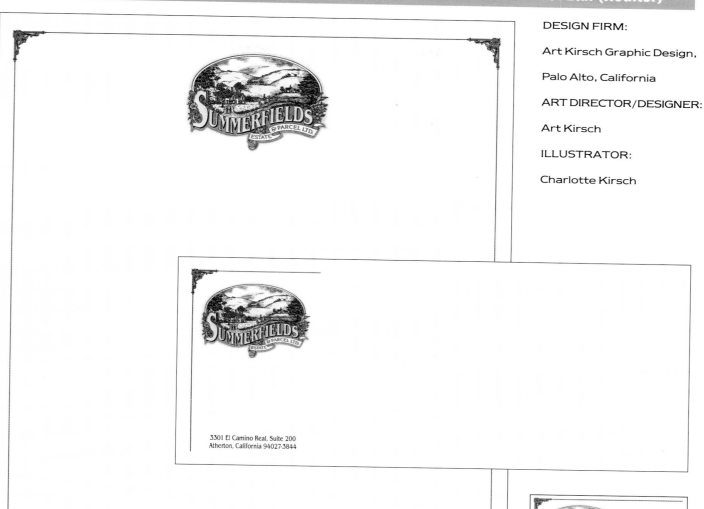

DESIGN FIRM:

Art Kirsch Graphic Design,

Palo Alto, California

ART DIRECTOR/DESIGNER:

Art Kirsch

ILLUSTRATOR:

Charlotte Kirsch

3301 El Camino Real, Suite 200
Atherton, California 94027-3844

3301 El Camino Real, Suite 200, Atherton, California 94027-3844 ❦ Telephone 415-324-4600 or 415-851-1200, Telecopier 415-365-1645

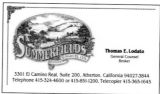

**Thomas E. Lodato**
General Counsel
Broker

3301 El Camino Real, Suite 200, Atherton, California 94027-3844
Telephone 415-324-4600 or 415-851-1200, Telecopier 415-365-1645

3301 El Camino Real, Suite 200
Atherton, California 94027-3844

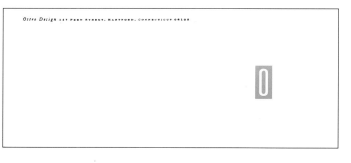

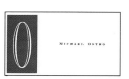

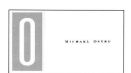

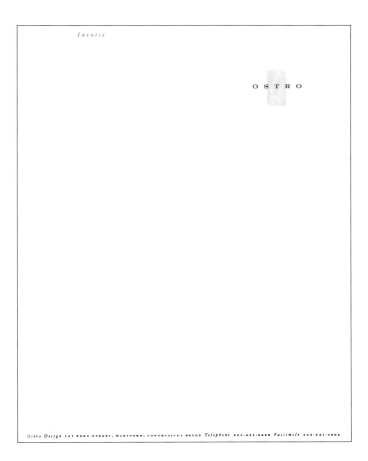

DESIGN FIRM:

Ostro Design, Hartford ,

Connecticut

ART DIRECTOR/DESIGNER:

Michael Ostro

TYPOGRAPHY:

Mono Typesetting

PRINTERS:

Swanson Engraving,

Briarwood Printing Co.

## Ostro Design

DESIGN FIRM:

Eymer Design, Boston,

Massachusetts

ART DIRECTOR:

Douglas Eymer

DESIGNERS:

Douglas and Selene

Eymer

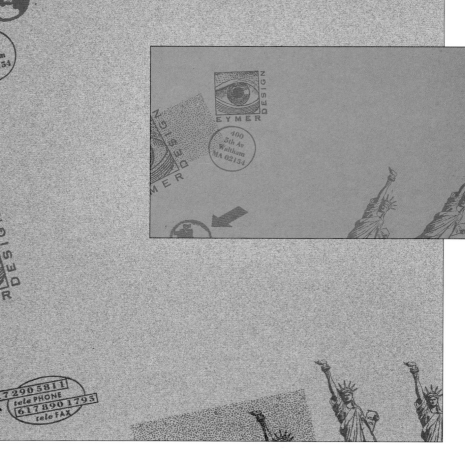

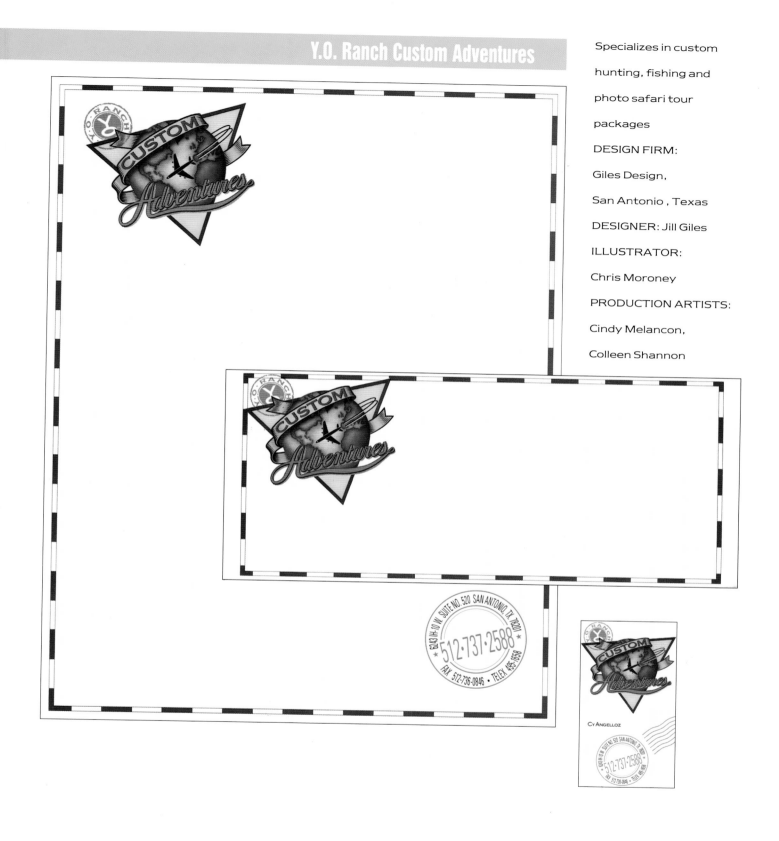

Specializes in custom hunting, fishing and photo safari tour packages

DESIGN FIRM: Giles Design, San Antonio , Texas

DESIGNER: Jill Giles

ILLUSTRATOR: Chris Moroney

PRODUCTION ARTISTS: Cindy Melancon, Colleen Shannon

LIGHTWORKS

*Corporate Communications Services*

16013 SOUTHEAST 31ST. BELLEVUE WA 98008

TELEPHONE/FACSIMILE ● (206)641-7687

LIGHTWORKS

*Corporate Communications Services*

16013 SOUTHEAST 31ST BELLEVUE WA 98008

TELEPHONE/FACSIMILE ● (206)641-7687

*Lesa Lighthourne*

DESIGN FIRM:

Graphic Associates,

Bellevue, Washington

ART DIRECTOR/DESIGNER:

Diana Loback

ILLUSTRATOR:

Wallace Lloyd

**Lightworks (Corporate Communications Services)**

DESIGN FIRM:

O'Hare & Olsen Design

Associates, Vero Beach,

Florida

ART DIRECTOR/DESIGNER:

Terri O'Hare

**KRIEGHOFF**

P.O. BOX 3528, BEACH STATION, VERO BEACH, FLORIDA 32964-3528
1-800-73-K-GUNS · 407-231-1221 · 407-231-6503 FAX

**KRIEGHOFF**
GUN COMPANY

S. HALLOCK DU PONT, JR.

P.O. BOX 3528, BEACH STATION, VERO BEACH, FLORIDA 32964-3528
1-800-73-K-GUNS · 407-231-1221 · 407-231-6503 FAX

**Krieghoff Gun Co.**

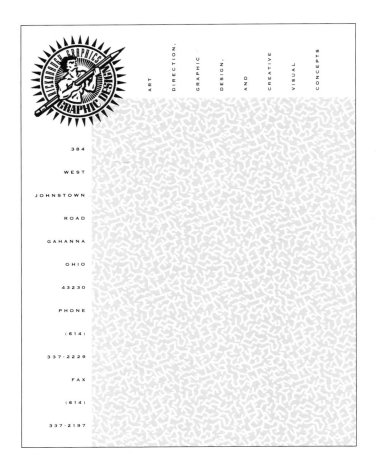

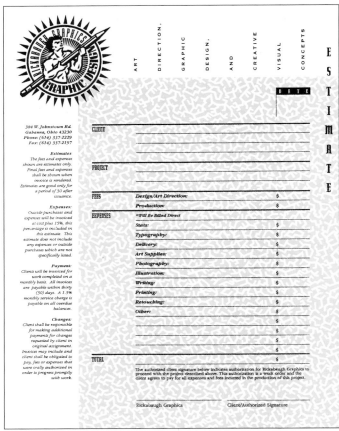

384 W. Johnstown Rd.
Gahanna, Ohio 43230
Phone: (614) 337-2229
Fax: (614) 337-2197

**Estimates**
The fees and expenses
shown are estimates only.
Final fees and expenses
shall be shown when
invoice is rendered.
Estimates are good only for
a period of 30 after
issuance.

**Expenses:**
Outside purchases and
expenses will be invoiced
at cost plus 15%, this
percentage is included in
this estimate. This
estimate does not include
any expenses or outside
purchases which are not
specifically listed.

**Payment:**
Clients will be invoiced for
work completed on a
monthly basis. All invoices
are payable within thirty
(30) days. A 1.5%
monthly service charge is
payable on all overdue
balances.

**Changes:**
Client shall be responsible
for making additional
payments for changes
requested by client in
original assignment.
Invoices may include and
client shall be obligated to
pay, fees or expenses that
were orally authorized in
order to progress promptly
with work.

**ESTIMATE**

**DATE**

| CLIENT | | |
|---|---|---|
| PROJECT | | |

| FEES | Design/Art Direction: | $ |
|---|---|---|
| | Production: | $ |
| EXPENSES | *Will Be Billed Direct | |
| | Stats: | $ |
| | Typography: | $ |
| | Delivery: | $ |
| | Art Supplies: | $ |
| | Photography: | $ |
| | Illustration: | $ |
| | Writing: | $ |
| | Printing: | $ |
| | Retouching: | $ |
| | Other: | $ |
| | | $ |
| | | $ |
| | | $ |
| TOTAL | | $ |

The authorized client signature below indicates authorization for Rickabaugh Graphics to proceed with the project described above. This authorization is a work order and the client agrees to pay for all expenses and fees incurred in the production of this project.

Rickabaugh Graphics                    Client/Authorized Signature

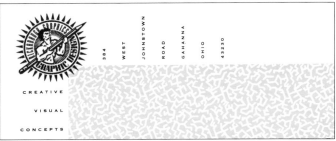

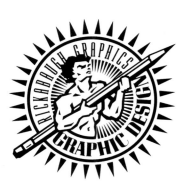

**DESIGN FIRM:**

Rickabaugh Graphics,

Gahanna, Ohio

**ART DIRECTOR/DESIGNER/**

**ILLUSTRATOR:**

Eric Rickabaugh

**PRODUCTION:**

Tony Meuser

**Rickabaugh Graphics**

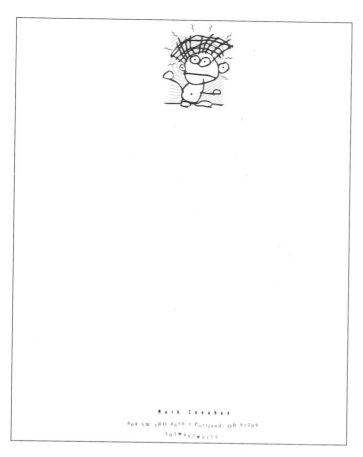

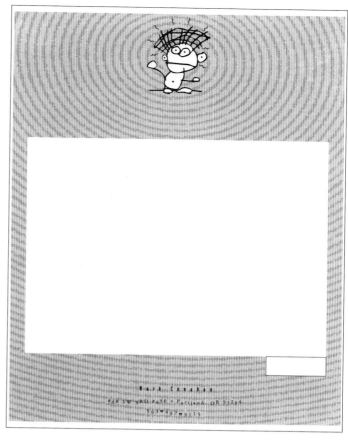

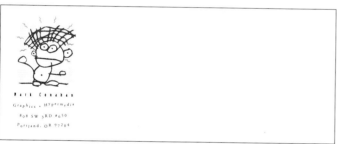

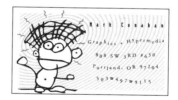

DESIGN FIRM:

Mark Conahan Graphics,

Portland, Oregon

DESIGNER:

Mark Conahan

ILLUSTRATOR:

Gillian Conahan

DESIGNER:

Anna Stilianaki,

New York, New York

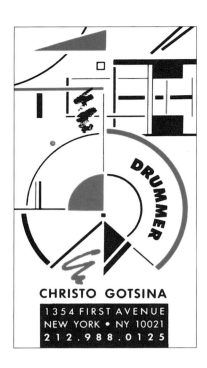

DESIGNER:

Candice Swanson,

Fort Worth, Texas

**Bb**

**Bridget Barry**
COPYWRITER
(817) 292-5764

5025 Overton Ridge Cir., #1728
Fort Worth, TX 76132

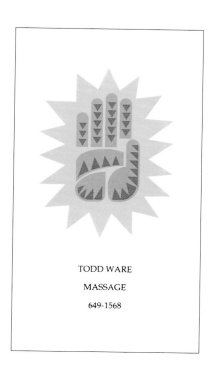

TODD WARE

MASSAGE

649-1568

DESIGN FIRM:

The Weller Institute for the

Cure of Design, Inc.,

Park City, Utah

ART DIRECTOR/DESIGNER/

ILLUSTRATOR: Don Weller

## Todd Ware Massage

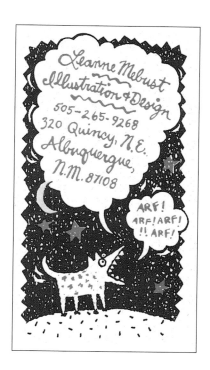

ART DIRECTOR:

Leanne Mebust,

Albuquerque, New Mexico

DESIGNER/ILLUSTRATOR:

Leanne Mebust

## Leanne Mebust (Designer/Illustrator)

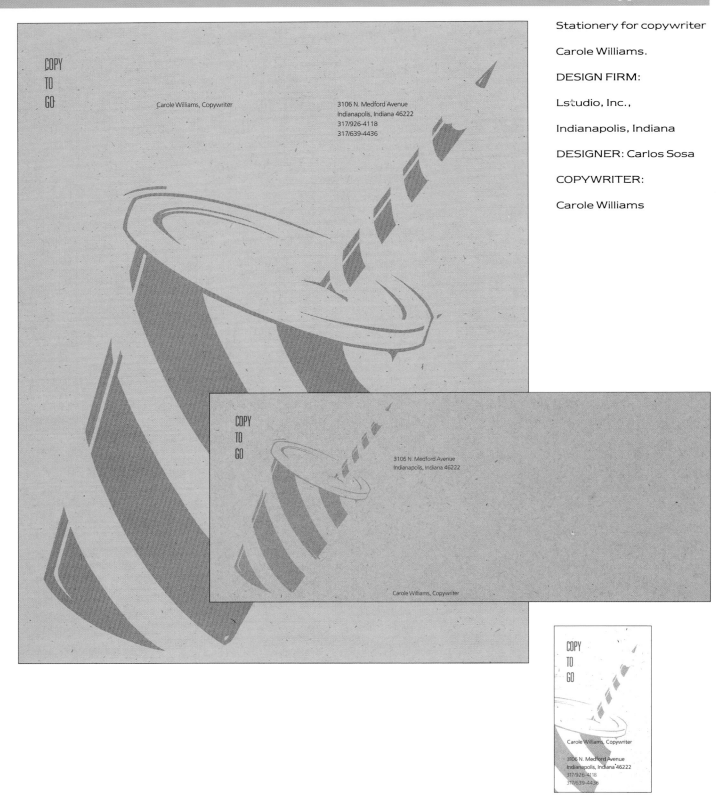

Stationery for copywriter

Carole Williams.

DESIGN FIRM:

Lstudio, Inc.,

Indianapolis, Indiana

DESIGNER: Carlos Sosa

COPYWRITER:

Carole Williams

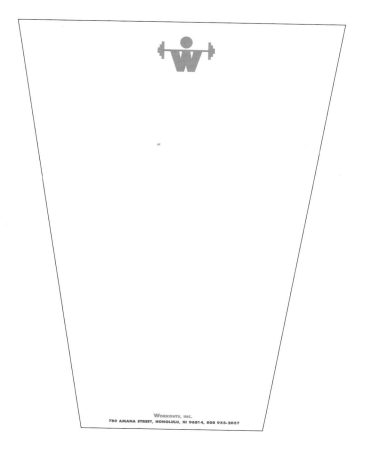

**DESIGN FIRM:**

Info Grafik, Honolulu, Hawaii

**CREATIVE DIRECTOR/ ART DIRECTOR:**

Oren Schlieman

**DESIGNERS:**

Oren Schlieman, Earl Yoshii

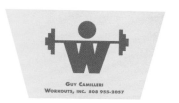

Workouts, Inc.

DESIGN FIRM:

Tharp Did It,

Los Gatos, California

DESIGNER: Rick Tharp

COPYWRITER:

David Hansmith

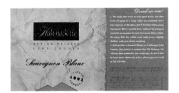

*Kah·nock'tie*

KAH·NOCK·TIE IS
KONOCTI WINERY
IN CALIFORNIA'S
LAKE COUNTY.
OUR WINERY IS
NAMED AFTER
MOUNT KONOCTI,
THE VOLCANO
THAT DOMINATES
OUR LANDSCAPE.
KONOCTI WINERY
P.O. BOX 890
HIGHWAY 29
AT THOMAS DRIVE
KELSEYVILLE
CALIFORNIA 95451
PHONE 707.279.8861
F A X 707.279.9633

KONOCTI WINERY
P.O. BOX 890
HIGHWAY 29
AT THOMAS DRIVE
KELSEYVILLE
CALIFORNIA 95451

114

DESIGN FIRM:

Yumi Hamano Graphic

Design, Redonda Beach,

California

ART DIRECTOR/DESIGNER/

ILLUSTRATOR: Yoshi Ueda

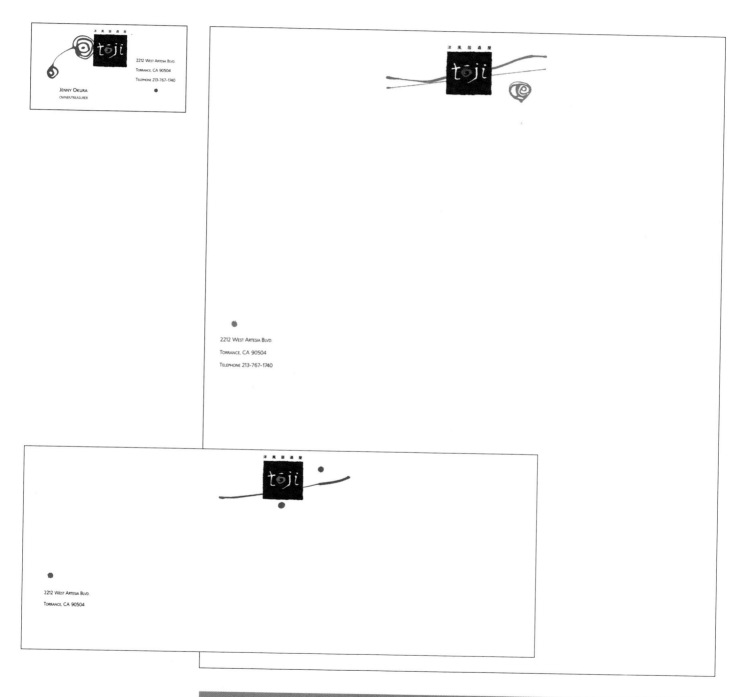

**Izakaya Toji (Restaurant)**

S T O N E    S O U P    P R O D U C T I O N S , I N C

**DESIGN FIRM:**

Logan Design, Glendale,

California

**ART DIRECTOR/DESIGNER:**

Raymond Logan

**ILLUSTRATORS:**

Raymond Logan,

Keewon Hong

2219 MAIN STREET, SUITE A-1, SANTA MONICA, CA 90405
TELEPHONE: 310/314-6306 FACSIMILE: 310/314-6308

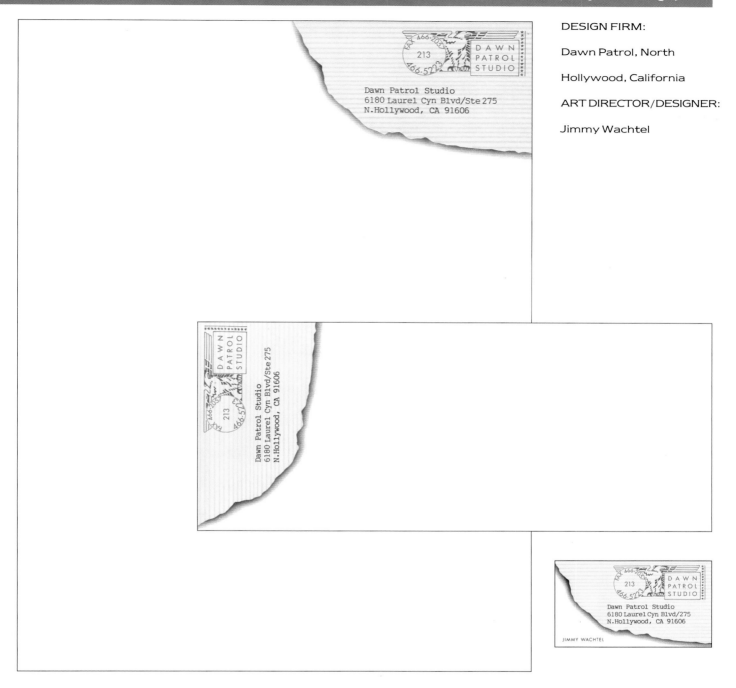

DESIGN FIRM:

Dawn Patrol, North

Hollywood, California

ART DIRECTOR/DESIGNER:

Jimmy Wachtel

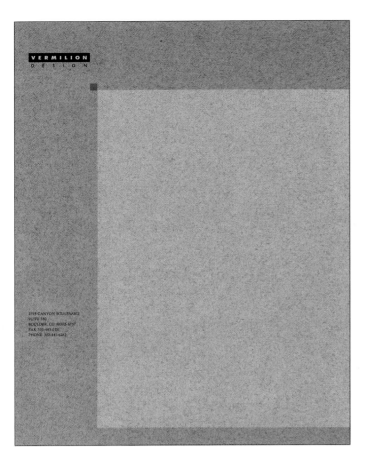

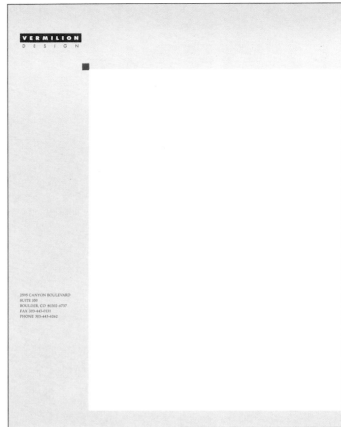

DESIGN FIRM:

Vermilion Design,

Boulder, Colorado

ART DIRECTOR:

Robert Morehouse

DESIGNER:

Vermilion Design

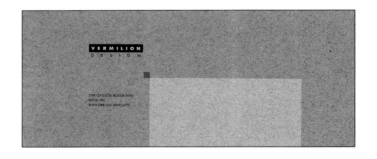

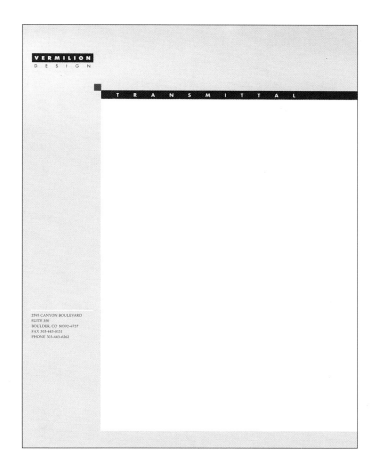

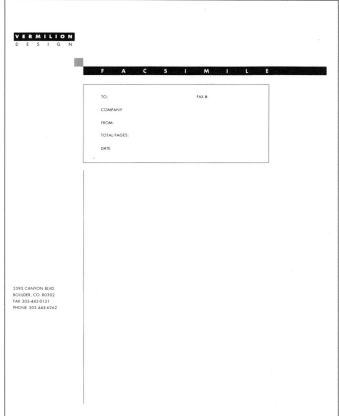

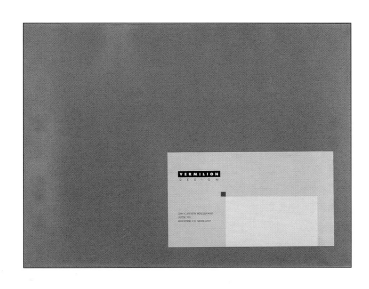

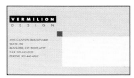

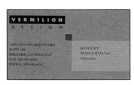

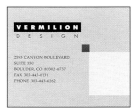

Vermilion Design

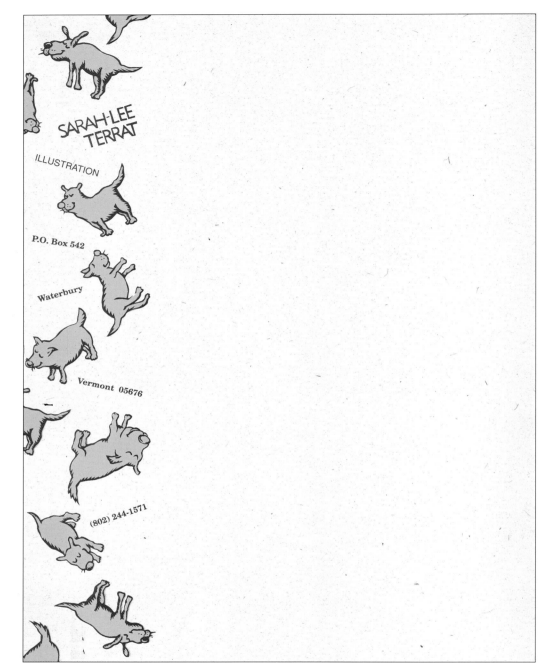

ART DIRECTOR/DESIGNER/

ILLUSTRATOR:

Sarah-Lee Terrat,

Waterbury, Vermont

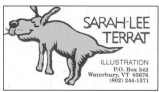

## City of Phoenix

Stationery for public-awareness program in the areas of fire and water safety.

DESIGN FIRM:

Richardson or Richardson, Phoenix, Arizona

ART DIRECTOR:

Forrest Richardson

DESIGNER/ILLUSTRATOR:

Beth Royalty

**PHOENIX FIRE-PAL**

520 West Van Buren

Phoenix, Arizona 85003

602-262-6910

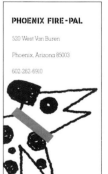

**PHOENIX FIRE-PAL**

520 West Van Buren

Phoenix, Arizona 85003

602-262-6910

Steve Jensen

Department Liaison

Precision thermoset
plastics molder of parts
used in the electronics and
aerospace industries.
DESIGN FIRM:
DRC Design, Feeding Hills,
Massachusetts
ART DIRECTOR/DESIGNER:
David Cecchi

ELM INDUSTRIES, INCORPORATED
*precision thermoset molding*
ESTABLISHED 1967

380 Union Street, West Springfield, Massachusetts 01089 U.S.A.
Telephone 413.734.7762 or 800.223.6586 Fax 413.731.7709

**Elm Industries**

DESIGN FIRM:

Gil Shuler Graphic Design, Inc.,

Charleston, South Carolina

ART DIRECTOR/DESIGNER:

Gil Shuler

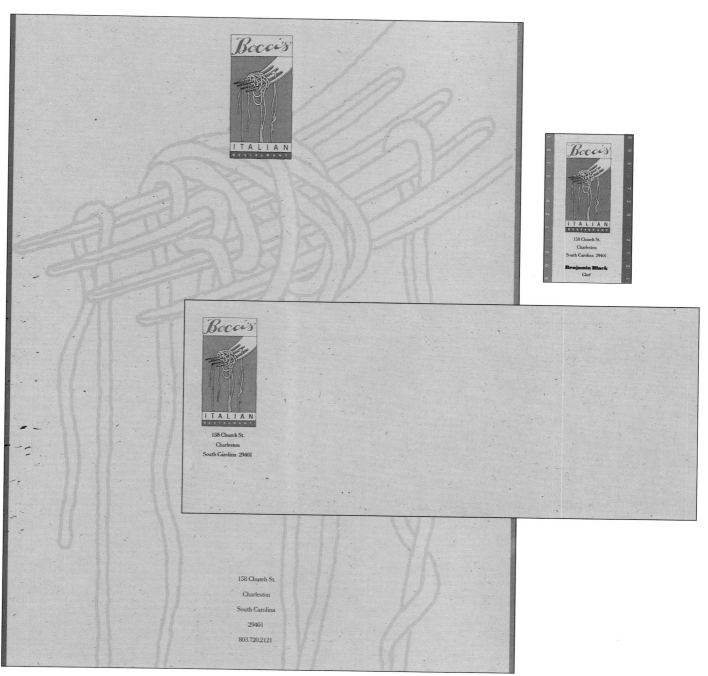

Bocci's Italian Restaurant

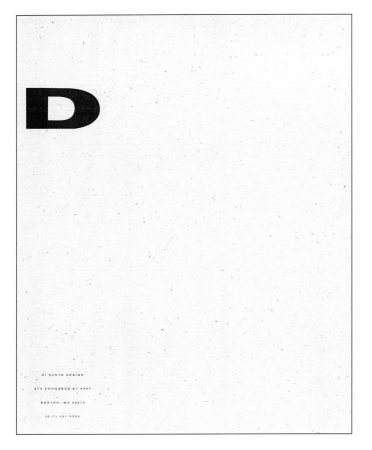

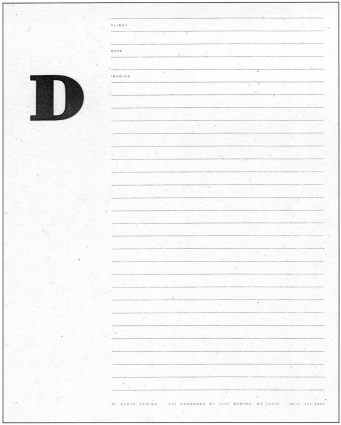

**DESIGN FIRM:**

DiSanto Design, Boston,

Massachusetts

**DESIGNER:** Rose DiSanto

**TYPOGRAPHY:**

Berkeley Typographers

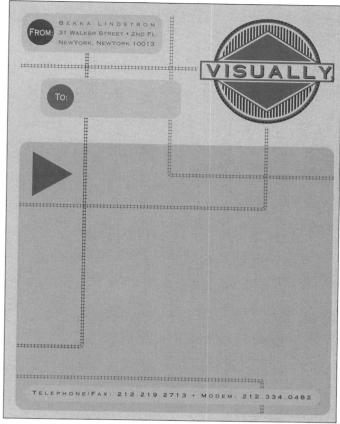

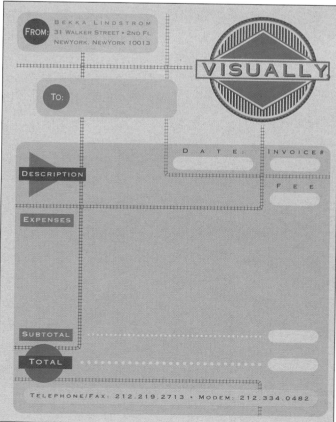

DESIGN FIRM: Visually,

New York, New York

ART DIRECTOR/DESIGNER:

Bekka Lindstrom

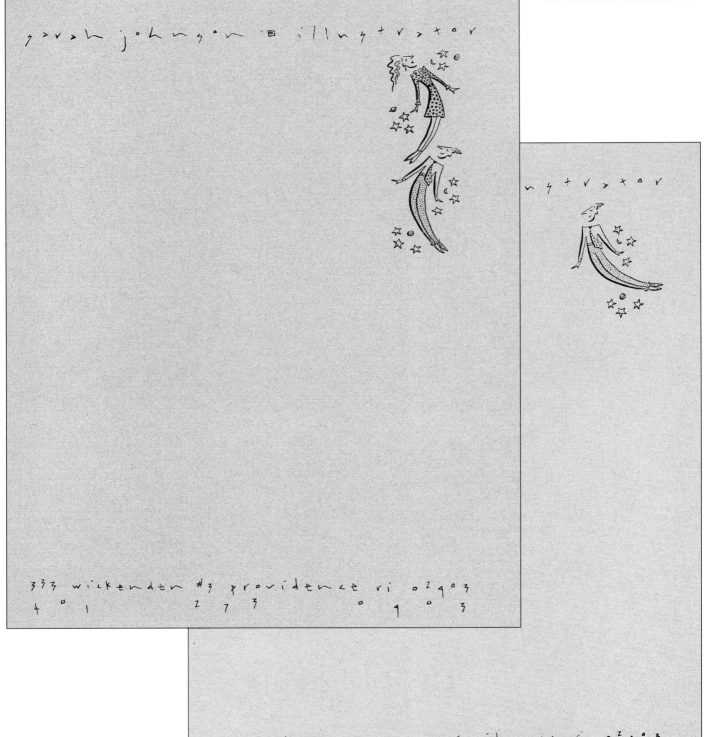

DESIGNER/ILLUSTRATOR:

Sarah Johnson,

Providence, Rhode Island

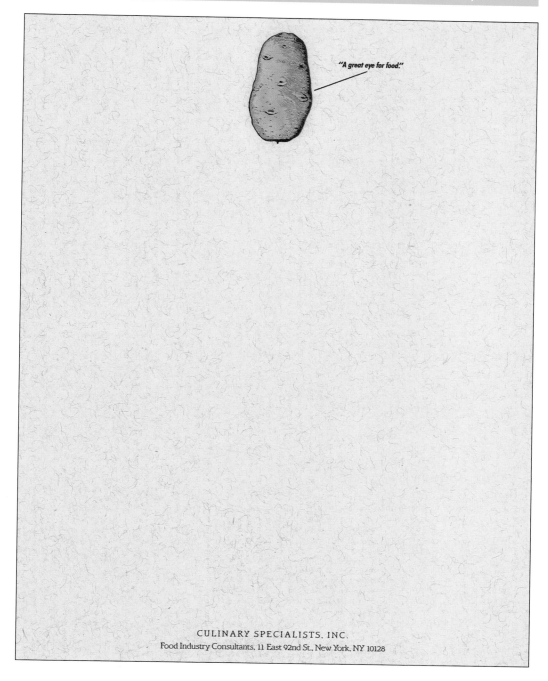

"A great eye for food."

CULINARY SPECIALISTS, INC.
Food Industry Consultants, 11 East 92nd St., New York, NY 10128

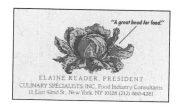

"A great head for food."

ELAINE READER, PRESIDENT
CULINARY SPECIALISTS, INC., Food Industry Consultants
11 East 92nd St., New York, NY 10128 (212) 860-4281

**DESIGN FIRM:**

Trousdell Design, Inc.,

Atlanta, Georgia

**ART DIRECTOR:**

Don Trousdell

**DESIGNER:**

Tamila Grogan

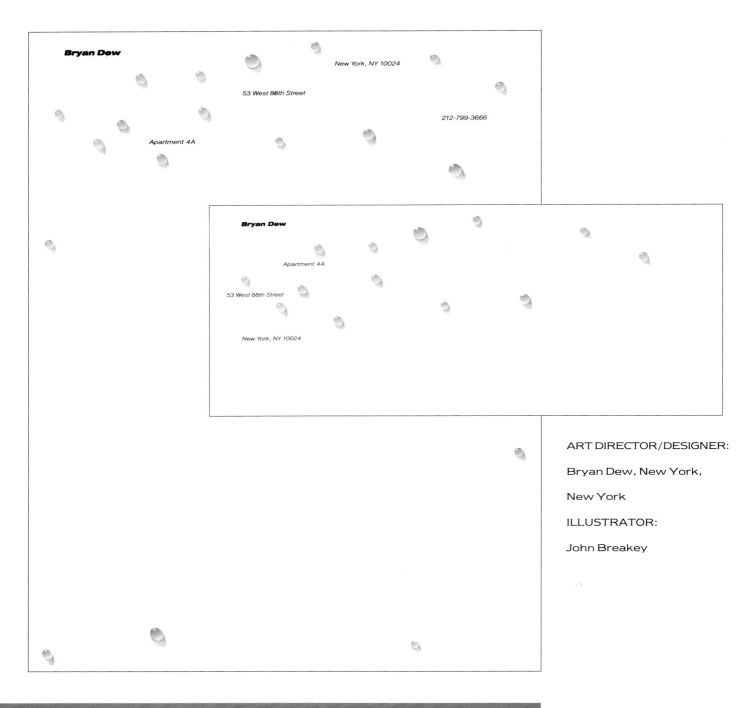

**Bryan Dew**

New York, NY 10024

53 West 88th Street

212-799-3666

Apartment 4A

**Bryan Dew**

Apartment 4A

53 West 88th Street

New York, NY 10024

ART DIRECTOR/DESIGNER:

Bryan Dew, New York,

New York

ILLUSTRATOR:

John Breakey

**Bryan Dew**

GEORGIA EYE BANK INC.

1327 CLIFTON ROAD N.E.        ATLANTA, GEORGIA 30322        (404) 321-9300        FAX (404) 248-5130        (800)-342-9812

**Georgia Eye Bank**

DESIGN FIRM:

Trousdell Design, Atlanta,

Georgia

ART DIRECTOR/DESIGNER:

Brett Trousdell

**129**

## Wood Dreams (Woodworker/Carpenter)

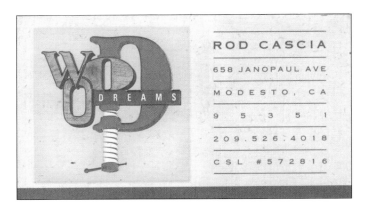

DESIGN FIRM:

Never Boring Design

Associates, Modesto,

California

ART DIRECTOR:

David Boring

DESIGNER/ILLUSTRATOR:

Brian Smith

DESIGN FIRM:

Vita/Design, Seattle,

Washington

ART DIRECTOR/DESIGNER:

Vita Otrubova

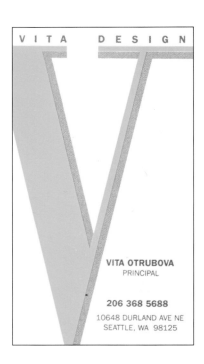

## Vita Otrubova

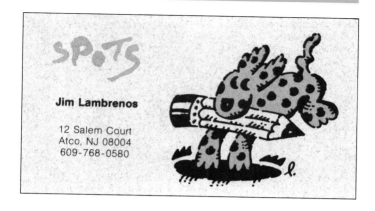

Business card designed to accompany spot illustration promotion folder.

DESIGN FIRM:

Jim Lambrenos, Atco, New Jersey

ART DIRECTOR/DESIGNER/ ILLUSTRATOR:

Jim Lambrenos

DESIGN FIRM:

Blue Stocking Designs, Roseland, New Jersey

ART DIRECTOR/DESIGNER:

Joan B. Slater

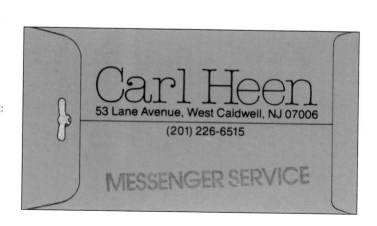

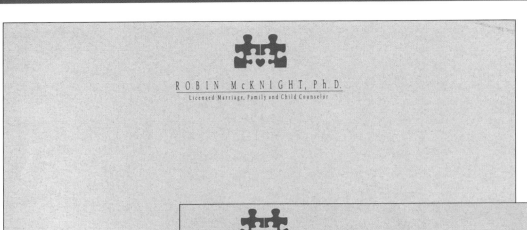

DESIGN FIRM:

Pat Davis Design,

Sacramento, California

ART DIRECTOR:

Pat Davis

DESIGNER:

Tracey Christian

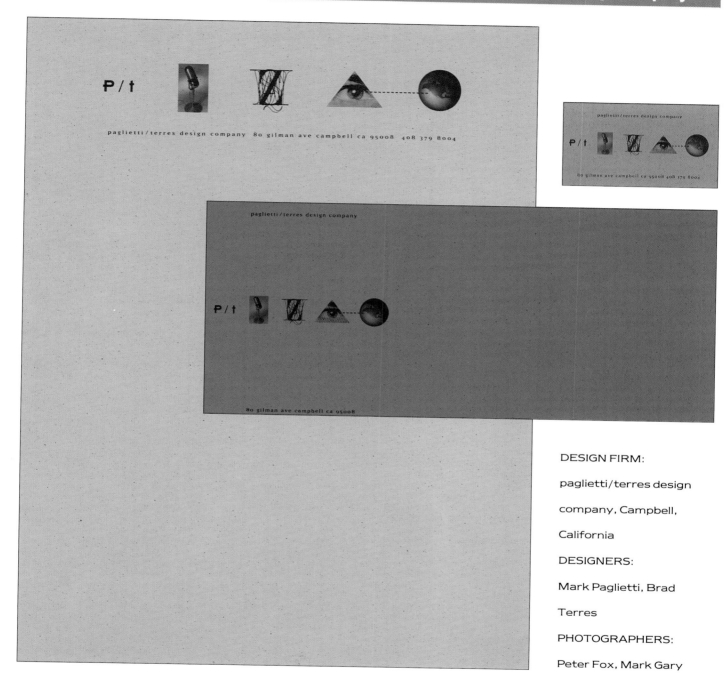

DESIGN FIRM:

paglietti/terres design

company, Campbell,

California

DESIGNERS:

Mark Paglietti, Brad

Terres

PHOTOGRAPHERS:

Peter Fox, Mark Gary

DESIGN FIRM:

Liz West Design, Melrose

Park, Pennsylvania

DESIGNER: Liz West

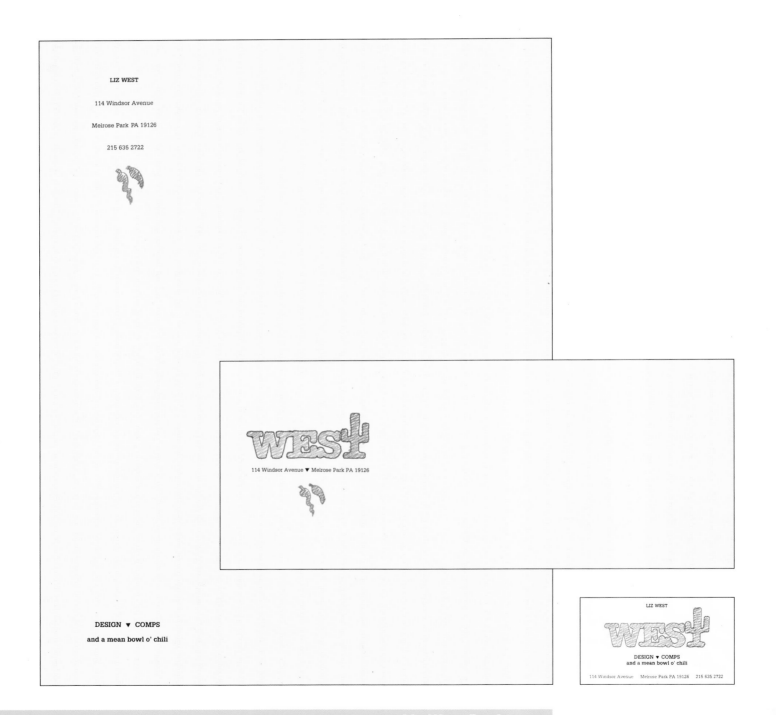

LIZ WEST

114 Windsor Avenue

Melrose Park PA 19126

215 635 2722

114 Windsor Avenue ▼ Melrose Park PA 19126

DESIGN ▼ COMPS

and a mean bowl o' chili

LIZ WEST

DESIGN ▼ COMPS
and a mean bowl o' chili

114 Windsor Avenue    Melrose Park PA 19126    215 635 2722

Liz West Design

Stationery for 1992 sales
meeting.
DESIGN FIRM:
Trousdell Design, Atlanta,
Georgia
ART DIRECTOR/DESIGNER:
Don Trousdell
ILLUSTRATOR:
Kelley Maddox

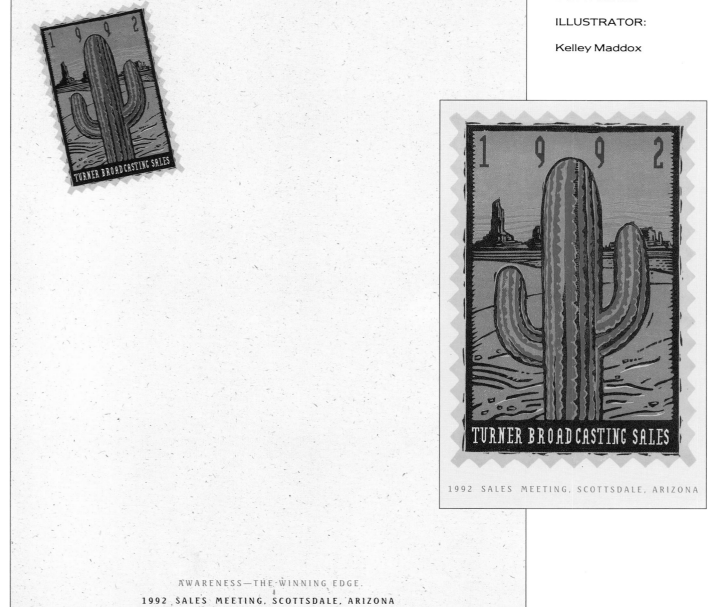

AWARENESS—THE WINNING EDGE.
1992 SALES MEETING, SCOTTSDALE, ARIZONA

## Turner Broadcasting Systems

DESIGN FIRM:

Graphic Associates,

Bellevue, Washington

ART DIRECTOR:

Marlice Thurtle

DESIGNER: Diana Loback

PUBLIC RELATIONS:

Cloud Public Relations

DESIGN FIRM:

Smit Ghormley Lofgreen

Design, Phoenix, Arizona

DESIGNER:

Brad Ghormley

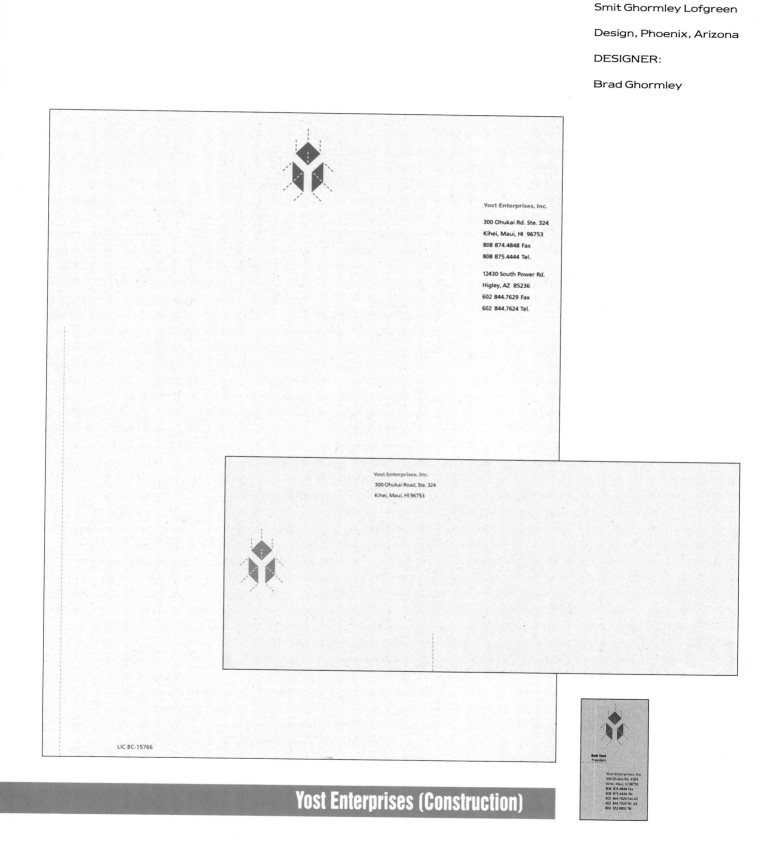

Yost Enterprises, Inc.

300 Ohukai Rd. Ste. 324
Kihei, Maui, HI 96753
808 874.4848 Fax
808 875.4444 Tel.

12430 South Power Rd.
Higley, AZ 85236
602 844.7629 Fax
602 844.7624 Tel.

Yost Enterprises, Inc.
300 Ohukai Road, Ste. 324
Kihei, Maui, HI 96753

LIC BC-15766

**Yost Enterprises (Construction)**

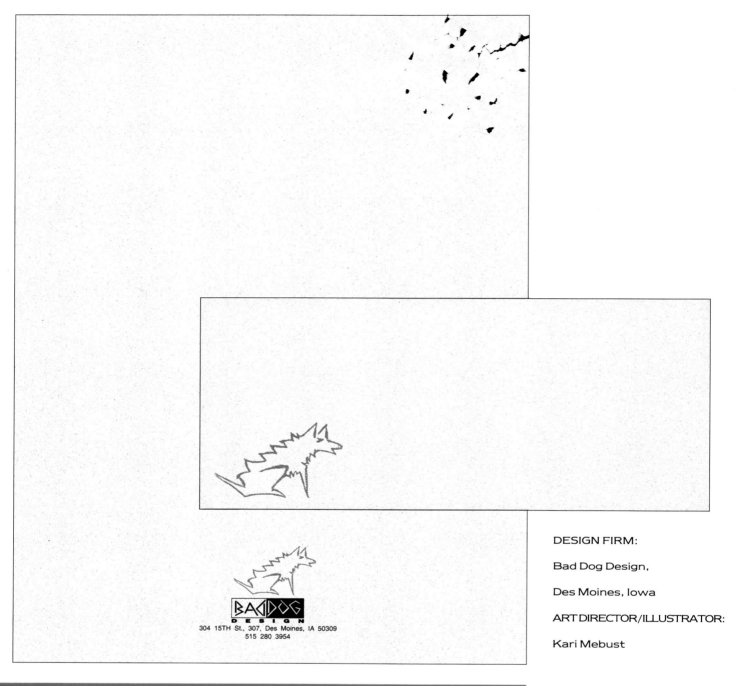

DESIGN FIRM:

Bad Dog Design,

Des Moines, Iowa

ART DIRECTOR/ILLUSTRATOR:

Kari Mebust

**Bad Dog Design**

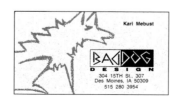

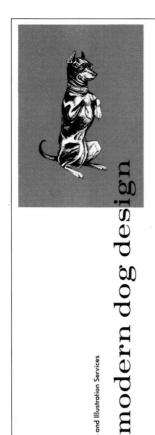

Graphic Design and Illustration Services

## modern dog design

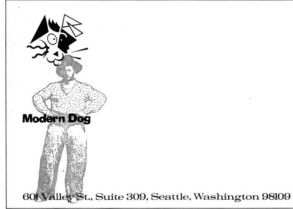

601 Valley St., Suite 309, Seattle, Washington 98109

601 Valley Street
Suite 309
Seattle, Washington
98109
tel. (206) 282-8857

Partners:
Robynne Raye
Michael Strassburger

Teaching an old world new tricks.

**Modern Dog**

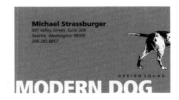

Michael Strassburger
601 Valley Street, Suite 309
Seattle, Washington 98109
206.282.8857

DESIGN SQUAD

MODERN DOG

DESIGN FIRM:

Modern Dog, Seattle,

Washington

ART DIRECTORS:

Robynne Raye,

Michael Strassburger

DESIGNER:

Michael Strassburger

DESIGN FIRM:

Box Fish Productions,

Makawao, Hawaii

ART DIRECTOR/DESIGNER:

Doug Pointer

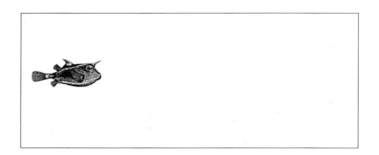

DESIGN FIRM:

Sancho Design, Seattle,

Washington

DESIGNER: Sancho

ART DIRECTOR/DESIGNER/
ILLUSTRATOR: Earl Gee,
San Francisco, California
TYPOGRAPHY:
Z Typography

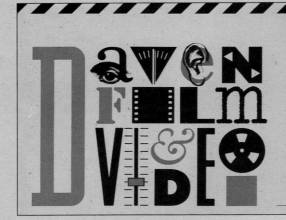

DAVEN FILM & VIDEO

500 LAGUNA STREET

SAN FRANCISCO CA

9  4  1  0  2

TEL 415 863 7173

FAX 415 863 7199

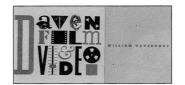

# Vital de Signs (Medical Illustration/Graphic Design)

DESIGN FIRM:

Vital de Signs, Chicago,

Illinois

ART DIRECTOR/DESIGNER/

ILLUSTRATOR:

Shiere M. Melin

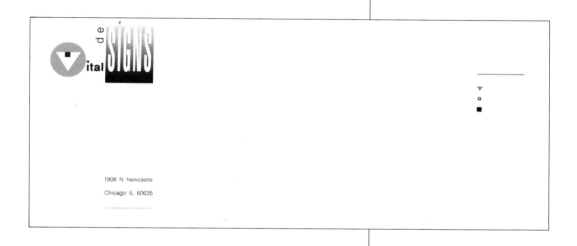

Shiere M Melin

1908 N Newcastle

Chicago IL 60635

312•889•7708

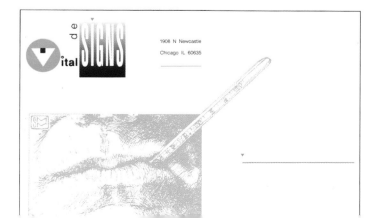

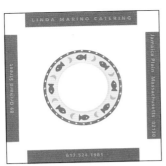
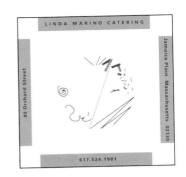
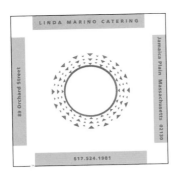

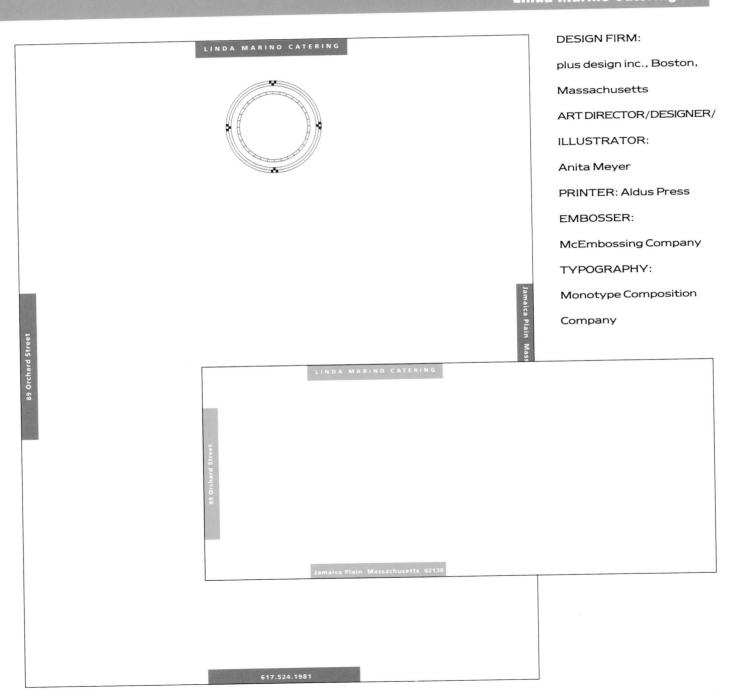

DESIGN FIRM:

plus design inc., Boston,

Massachusetts

ART DIRECTOR/DESIGNER/

ILLUSTRATOR:

Anita Meyer

PRINTER: Aldus Press

EMBOSSER:

McEmbossing Company

TYPOGRAPHY:

Monotype Composition

Company

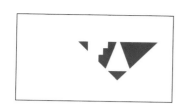

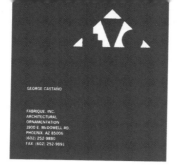

GEORGE CASTAÑO

FABRIQUE, INC.
ARCHITECTURAL
ORNAMENTATION
1900 E. McDOWELL RD.
PHOENIX, AZ 85006
(602) 252-9880
FAX (602) 252-9891

## Fabrique, Inc. (Architectural Ornamentation)

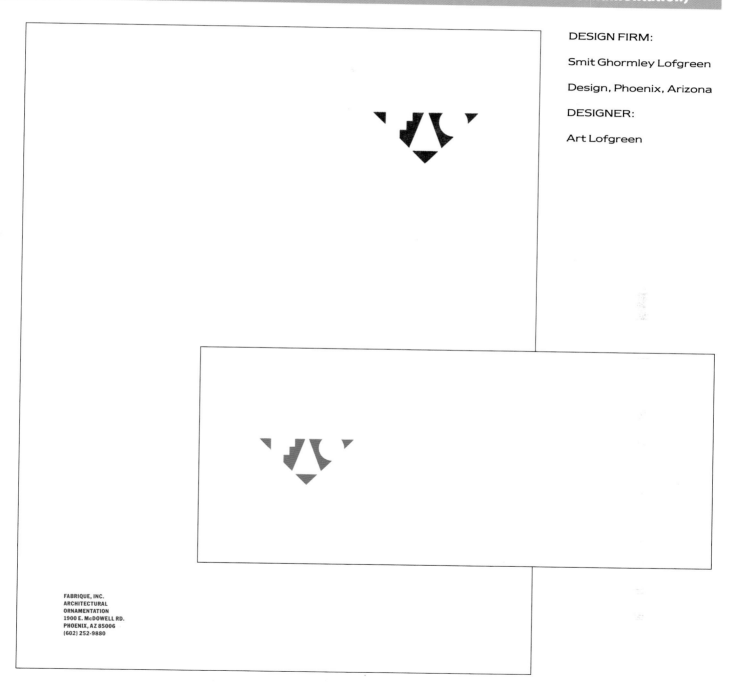

DESIGN FIRM:

Smit Ghormley Lofgreen

Design, Phoenix, Arizona

DESIGNER:

Art Lofgreen

FABRIQUE, INC.
ARCHITECTURAL
ORNAMENTATION
1900 E. McDOWELL RD.
PHOENIX, AZ 85006
(602) 252-9880

DESIGN FIRM:

Sprague/Hill, Dallas,

Texas

ART DIRECTOR:

Douglas J. Sprague

DESIGNERS:

Brad Hill, Douglas J.

Sprague

## Sprague/Hill

DESIGN FIRM:

The Creative Juice Factory,

Charlotte, North Carolina

ART DIRECTOR/

ILLUSTRATOR:

Rebecca Russell

DESIGNER: Jennifer Vilis

PRINTER:

Classic Graphics

TYPOGRAPHY:

Raven Type

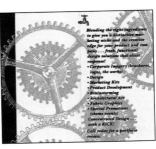

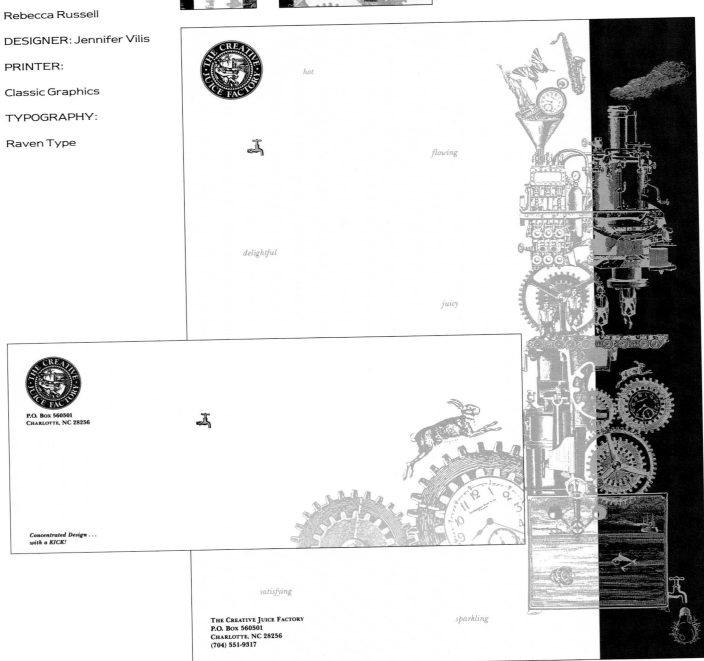

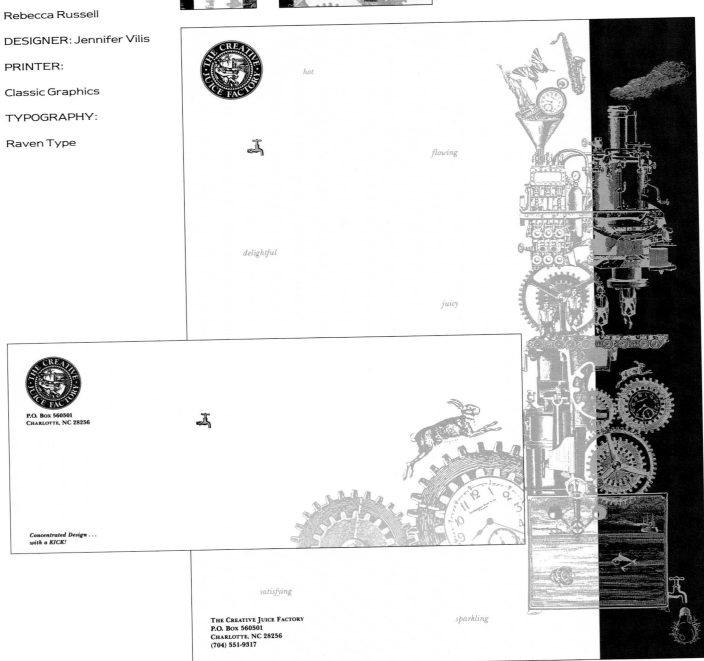

Stationery for The X Resource, a journal covering the issues and techniques in X (computer) programming.

DESIGN FIRM:
O'Reilly & Associates, Inc., Cambridge, Massachusetts
ART DIRECTOR/DESIGNER:
Edie Freedman

ARTIST:
Grandjean (18th century)

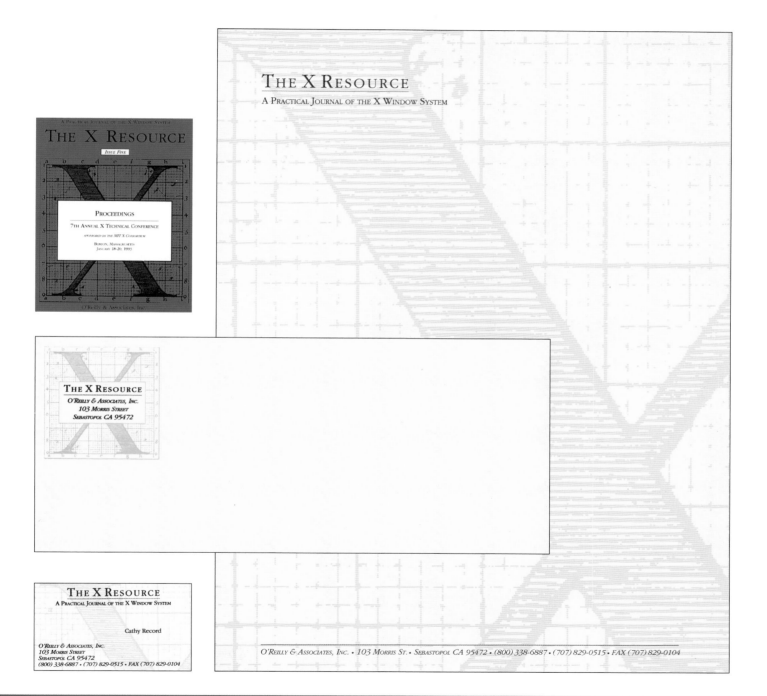

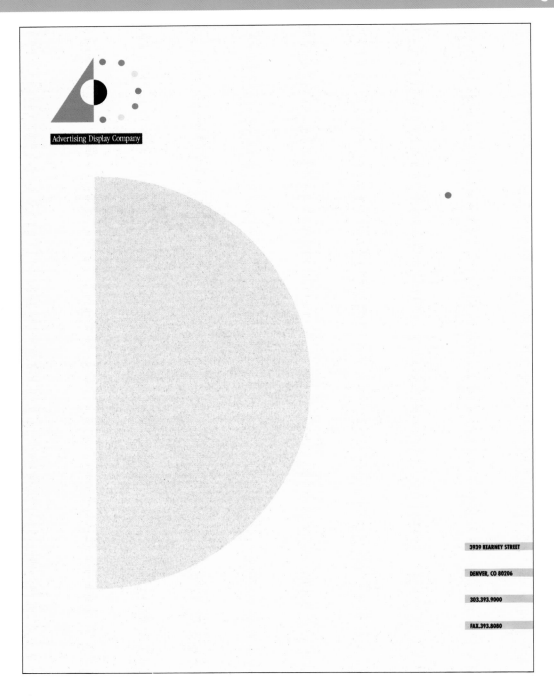

Advertising Display Company

3939 KEARNEY STREET

DENVER, CO 80206

303.393.9000

FAX.393.8080

DESIGN FIRM:

Merten Design Group,

Denver, Colorado

ART DIRECTOR:

Barry Merten

DESIGNER: Beth Parker

ART DIRECTOR/DESIGNER/

ILLUSTRATOR:

Kathryn Frund, West

Hartford, Connecticut

**CHAMBERLIN & DEVORE**
*LANDSCAPE ARCHITECTS*

ONE FALMOUTH ROAD
FAIRFIELD, CT 06430
203 372 1477
FAX 372 3525

ONE FALMOUTH ROAD FAIRFIELD, CT 06430

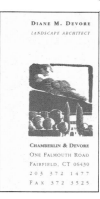

DIANE M. DEVORE
*LANDSCAPE ARCHITECT*

**CHAMBERLIN & DEVORE**
ONE FALMOUTH ROAD
FAIRFIELD, CT 06450
203 372 1477
FAX 372 3525

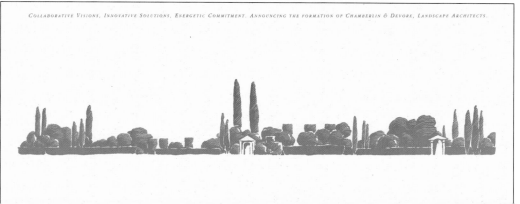

*COLLABORATIVE VISIONS, INNOVATIVE SOLUTIONS, ENERGETIC COMMITMENT. ANNOUNCING THE FORMATION OF CHAMBERLIN & DEVORE, LANDSCAPE ARCHITECTS.*

DESIGN FIRM:

Vaughn/Wedeen

Creative, Inc.,

Albuquerque, New Mexico

ART DIRECTORS:

Rick Vaughn, Steve

Wedeen

DESIGNER/ILLUSTRATOR:

Rick Vaughn

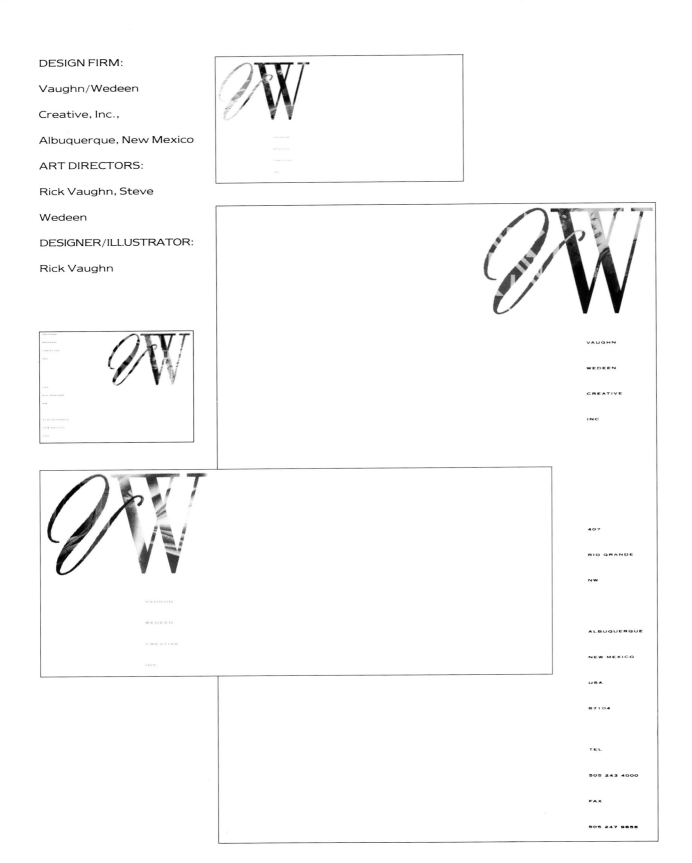

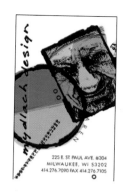

225 E. ST. PAUL AVE. #304 MILWAUKEE, WI 53202

MYDLACH DESIGN 225 E. ST. PAUL AVE. #304 MILWAUKEE, WI 53202 414.276.7090 FAX 414.276.7105

**Mydlach Design**

DESIGN FIRM:

Mydlach Design,

Milwaukee, Wisconsin

ART DIRECTOR/DESIGNER/

ILLUSTRATOR:

Karen Mydlach

PHOTOGRAPHER:

Brian Malloy Photography

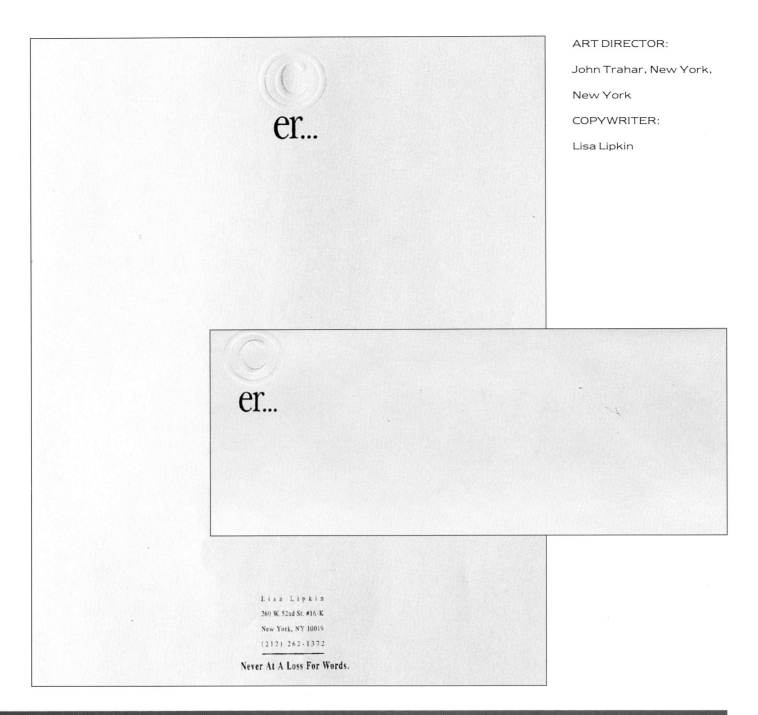

ART DIRECTOR:

John Trahar, New York,

New York

COPYWRITER:

Lisa Lipkin

Lisa Lipkin
260 W. 52nd St. #16-K
New York, NY 10019
(212) 262-1372

**Never At A Loss For Words.**

## Lisa Lipkin (Copywriter)

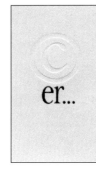

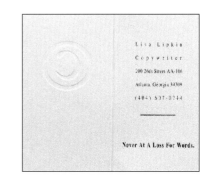

Lisa Lipkin
Copywriter
200 26th Street AA-166
Atlanta, Georgia 30309
(404) 537-0244

**Never At A Loss For Words.**

GOLF MANAGEMENT INTERNATIONAL

DESIGN FIRM:
Richardson or
Richardson, Phoenix,
Arizona
ART DIRECTORS:
Valerie Richardson,
Debi Young-Mees
ILLUSTRATORS:
Jim Bolek, Debi Young-
Mees
TYPOGRAPHY: Digitype
ENGRAVING:
Ponte Engraving

Phoenix, Arizona 85016
(602) 957 7510
Facsimile (602) 957-7512

**Golf Management International**

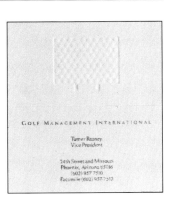

GOLF MANAGEMENT INTERNATIONAL

Turner Rooney
Vice President

24th Street and Missouri
Phoenix, Arizona 85016
(602) 957 7510
Facsimile (602) 957-7512

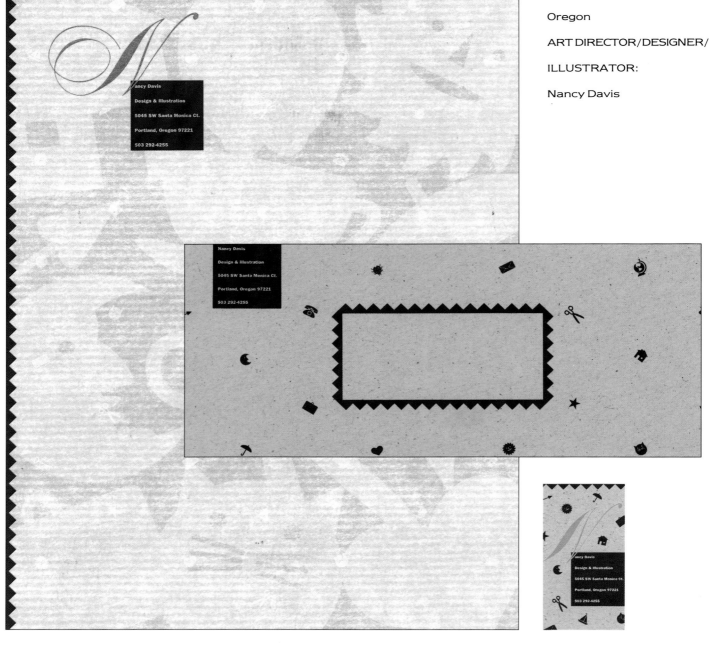

DESIGN FIRM:

Nancy Davis Design &

Illustration, Portland,

Oregon

ART DIRECTOR/DESIGNER/

ILLUSTRATOR:

Nancy Davis

DESIGN FIRM:

Tackett-Barbaria Design,

Sacramento, California

ART DIRECTORS:

Steve Barbaria, Kim

Tackett

DESIGNER:

Steve Barbaria

1990 3rd St. Suite 400

**TACKETT**

Sacramento, CA 95814

**BARBARIA**

Tel 916.442.3200

**DESIGN**

Fax 916.442.5243

1990 Third Street

**TACKETT**

Suite 400

**BARBARIA**

Sacramento

**DESIGN**

California 95814

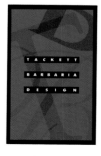

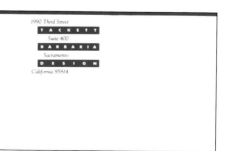

1990 Third Street

**TACKETT**

Suite 400

**BARBARIA**

Sacramento

**DESIGN**

California 95814

DESIGN FIRM:

MARK, Identity & Design,

San Francisco, California

ART DIRECTOR/DESIGNER:

Mark Landkamer

MASSINI

| Furniture | Pacific Design Center | Telephone 213 652 1060 |
| Lighting | 8687 Melrose Avenue | Fax 213 652 2208 |
| Planning | West Hollywood, CA 90069 | Telex 9102504356 Massini |

MASSINI

Furniture

Lighting

Planning

Massoud Amini

123 Townsend Street

Suite 470

San Francisco, CA 94107

Telephone 415 777 2207

Fax 415 777 1474

Telex 9102504356 Massini

## Massini (Furniture Showroom)

Stationery for Graphic
Design Dialogue, design
conference held in
Moscow and Leningrad.

DESIGN FIRM:
Clark/Linsky Design, Inc.,
Charlestown,
Massachusetts

ART DIRECTOR/DESIGNER:
Robert H. Linsky

A HISTORIC EVENT
THE FIRST AMERICAN-SOVIET
GRAPHIC DESIGN DIALOGUE
MOSCOW - LENINGRAD
AUGUST 1-13, 1990

A HISTORIC EVENT
THE FIRST AMERICAN-SOVIET
GRAPHIC DESIGN DIALOGUE
MOSCOW - LENINGRAD
AUGUST 1-13, 1990

73 Newbury Street, 4th Floor
Boston, Massachusetts 02116

**International Society of Graphic Designers**

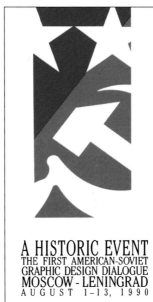

A HISTORIC EVENT
THE FIRST AMERICAN-SOVIET
GRAPHIC DESIGN DIALOGUE
MOSCOW - LENINGRAD
AUGUST 1-13, 1990

DESIGN FIRM:

Vaxworks, Berkeley,

California

ART DIRECTOR: Joe Vax

DESIGNERS: Joe Vax,

May Key Chung

## Yamamoto Moss, Inc.

DESIGN FIRM:

Yamamoto Moss, Inc.,

Minneapolis, Minnesota

ART DIRECTOR:

Gregory Pickman

DESIGNERS:

Donna Daubenbiek,

Gregory Pickman,

Hideki Yamamoto,

Miranda Moss

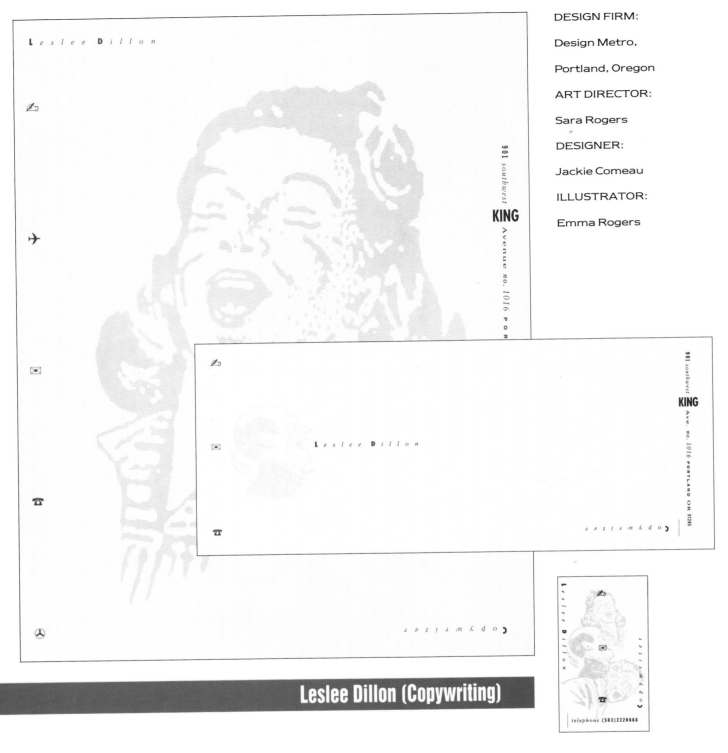

DESIGN FIRM:

Design Metro,

Portland, Oregon

ART DIRECTOR:

Sara Rogers

DESIGNER:

Jackie Comeau

ILLUSTRATOR:

Emma Rogers

**Leslee Dillon (Copywriting)**

162

Contract Design Consultants

Interior Design and Space Planning
3509 North Greenview Avenue
Chicago, Illinois 60657
312.528.0053

DESIGN FIRM:

Blevins Design,

Elmhurst, Illinois

ART DIRECTOR:

Brian Blevins

DESIGNER: Chris Blevins

Contract Design Consultants

Interior Design and Space Planning
3509 North Greenview Avenue
Chicago, Illinois 60657

Susan Sullivan
Contract Design Consultants

Interior Design and Space Planning
3509 North Greenview Avenue
Chicago, Illinois 60657
312.528.0053

# Contract Design Consultants (Interior Design)

Contract Design Consultants

Interior Design and Space Planning
3509 North Greenview Avenue
Chicago, Illinois 60657

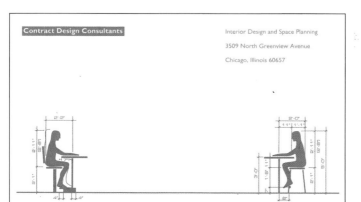

**163**

Boston Book Company
*& Book Annex*

ANTIQUARIAN
BOOKS

705 Centre Street
Boston, Massachusetts 02130
Telephone (617) 522-2100
Fax (617) 522-9359

Boston Book Company *& Book Annex*
ANTIQUARIAN BOOKS

705 Centre Street
Boston, Massachusetts 02130
Telephone (617) 522-2100
Fax (617) 522-9359

**Boston Book Company**

Boston Book Company
*& Book Annex*

ANTIQUARIAN
BOOKS

Boston Book Company *& Book Annex*
ANTIQUARIAN BOOKS

First Class
U.S. Postage
PAID
MA
Permit No. 55999

Rare and antiquarian book

dealers specializing in rare

Asian, particularly

Japanese, printed matter.

ART DIRECTOR/DESIGNER/

PHOTOGRAPHER:

Mary Ann Frye, Hingham,

Massachusetts

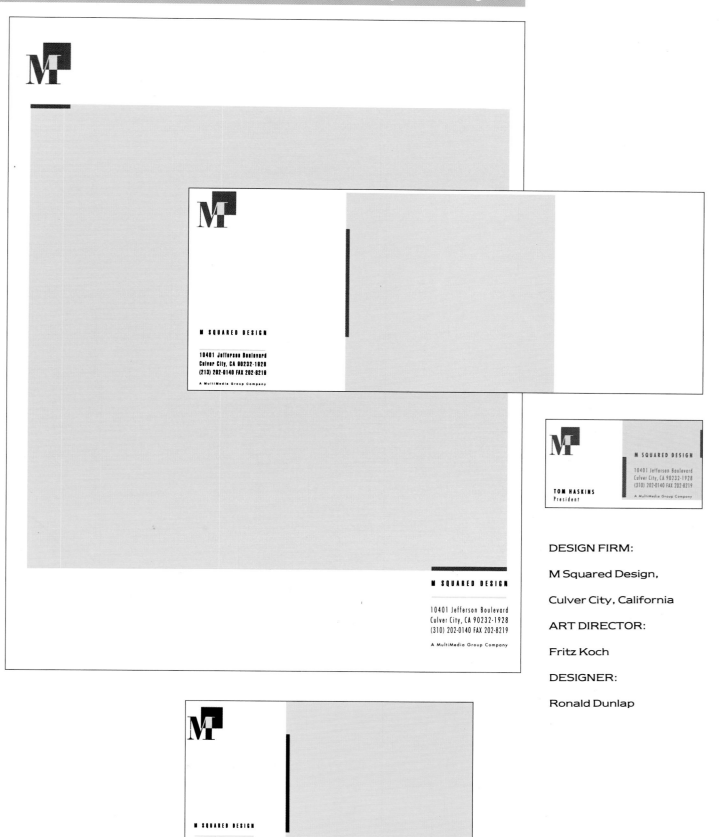

DESIGN FIRM:

M Squared Design,

Culver City, California

ART DIRECTOR:

Fritz Koch

DESIGNER:

Ronald Dunlap

Kevin Wade is a
screenwriter who lives
on Long Island.
DESIGN FIRM:
Richard Joy & Friends,
New York, New York
ART DIRECTOR/DESIGNER/
ILLUSTRATOR: Susan Wall

**Back East Pictures**

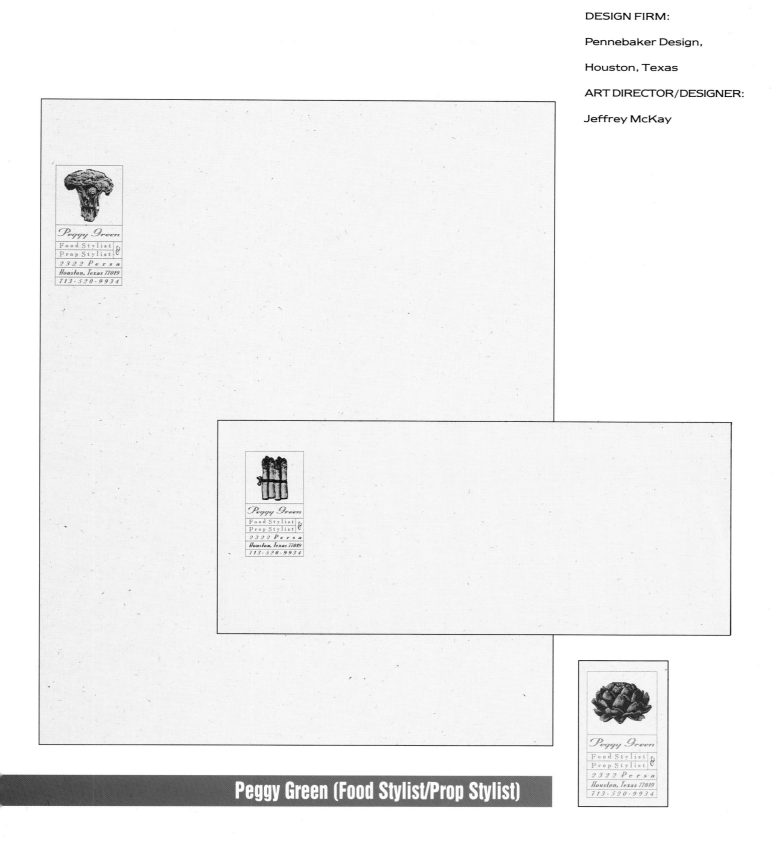

DESIGN FIRM:

Pennebaker Design,

Houston, Texas

ART DIRECTOR/DESIGNER:

Jeffrey McKay

**Peggy Green (Food Stylist/Prop Stylist)**

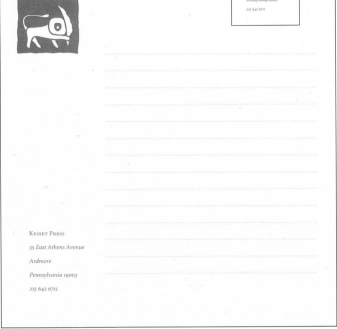

Kesset Press
35 East Athens Avenue
Ardmore
Pennsylvania 19003
215 642 6711

Kesset Press
35 East Athens Avenue
Ardmore
Pennsylvania 19003

**Kesset Press**
**Special Editions**

# Ketub
JEWISH MARRIAGE C

### Gates
The gates of the Holy City a
and contemporary architect
the Jerusalem illustration
Portions of the seventh wee
of joy and gladness, the wr
enclose the decorative bord

THE DECORATED KETUBAH is
expression of Jewish ritual a
years, the ketubah has be
wedding ceremony; decorat
homes of Jewish couples fo
    The Kesset Press Spe
internationally-renowned gr
Jonathan Kremer, continue
designed and meticulously
blend historical decorative n
with contemporary æsthet
in a limited edition on arch
enduring beauty and enjoy
    Kesset Press Special E
with a choice of texts (indic
following the edition num
servative (C), or Modern H

*Kesset Press*
*Special Editions*

### Welcome
Ever since Abraham and Sarah welcomed the three
angels into their abode, hospitality has been a hallmark
of the Jewish home. The spirit of this Biblically-derived
blessing is conveyed through a powerful graphic treat-
ment. Silkscreen printed in six colors. 12 x 18 inches.

THE LETTERING ARTS have long been a rich and significant
part of Jewish life, from the ancient writings of Biblical-
era scribes to the modern interpretations of contem-
porary artists. The Kesset Press Special Editions are
eloquent expressions of Hebrew texts by the interna-
tionally-renowned lettering artist Jonathan Kremer.
    Biblical, Rabbinic and liturgical writings are
among the sources for these inspired calligraphic works.
Timeless words of our heritage are given new perspective
through dynamic graphics and masterful use of color.
    Kesset Press Special Editions are meticulously
produced on archival-quality paper to assure enduring
beauty and enjoyment. Each print is signed in pencil
by the artist.

COPYRIGHT 1990 KESSET PRESS

Kesset Press
35 East Athens Avenue
Ardmore
Pennsylvania 19003
215 642 6711

Kesset Press
35 East Athens Avenue
Ardmore
Pennsylvania 19003
215 642 6711

Publisher of primarily
Jewish calligraphic
artwork.
DESIGN FIRM:
Jonathan Kremer Graphic
Design, Philadelphia,

Pennsylvania
ART DIRECTOR/DESIGNER/
ILLUSTRATOR:
Jonathan Kremer

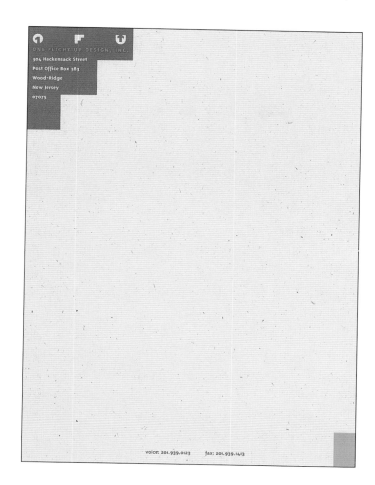

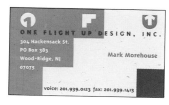

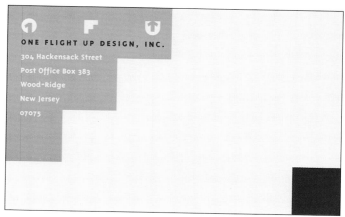

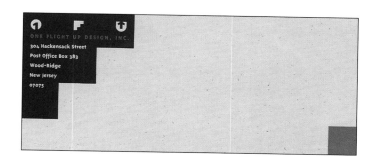

DESIGN FIRM:

One Flight Up Design, Inc.,

Woodridge, New Jersey

DESIGNERS:

Laura and Mark Morehouse,

Carol and Bill Stanhope

DESIGN FIRM:

Gardner + Greteman,

Wichita, Kansas

CREATIVE DIRECTORS/

ART DIRECTORS/DESIGNERS:

Bill Gardner, Sonia Greteman

4095 Route U. S. 1 · Suite 52-220 · Monmouth Junction, New Jersey 08852 · Telephone 609-936-0139

Michael A. Palisi
4095 Route U.S. 1, Suite 52-220
Monmouth Junction, N.J. 08852
Telephone 609-936-0139

DESIGN FIRM:

Pennebaker Design,

Houston, Texas

ART DIRECTOR/DESIGNER/

ILLUSTRATOR:

Haesun Kim Lerch

L  M  C    P  R  O  D  U  C  T  I  O  N  S

LMC PRODUCTIONS

4801 WOODWAY, SUITE 280E • HOUSTON, TEXAS 77056-1805 • 713 963 0397/800 767 0450 • FAX 713 960 9680

C. ANNE IRVIN

4801 WOODWAY
SUITE 280E
HOUSTON, TEXAS 77056
713 963 0397 / 800 767 0450
FAX 713 960 9680

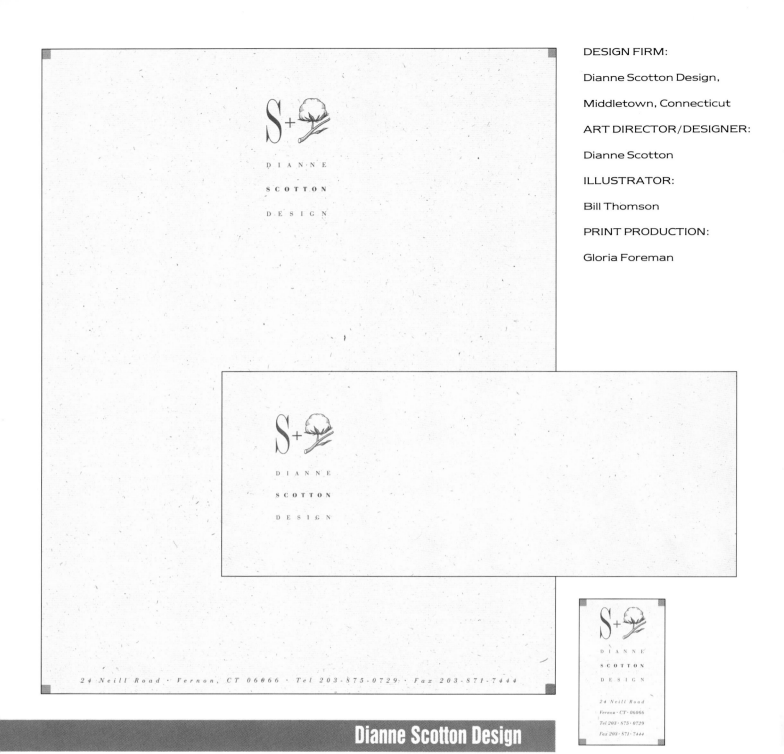

DESIGN FIRM:

Dianne Scotton Design,

Middletown, Connecticut

ART DIRECTOR/DESIGNER:

Dianne Scotton

ILLUSTRATOR:

Bill Thomson

PRINT PRODUCTION:

Gloria Foreman

24 Neill Road · Vernon, CT 06066 · Tel 203-875-0729 · Fax 203-871-7444

**Dianne Scotton Design**

24 Neill Road
Vernon · CT · 06066
Tel 203 · 875 · 0729
Fax 203 · 871 · 7444

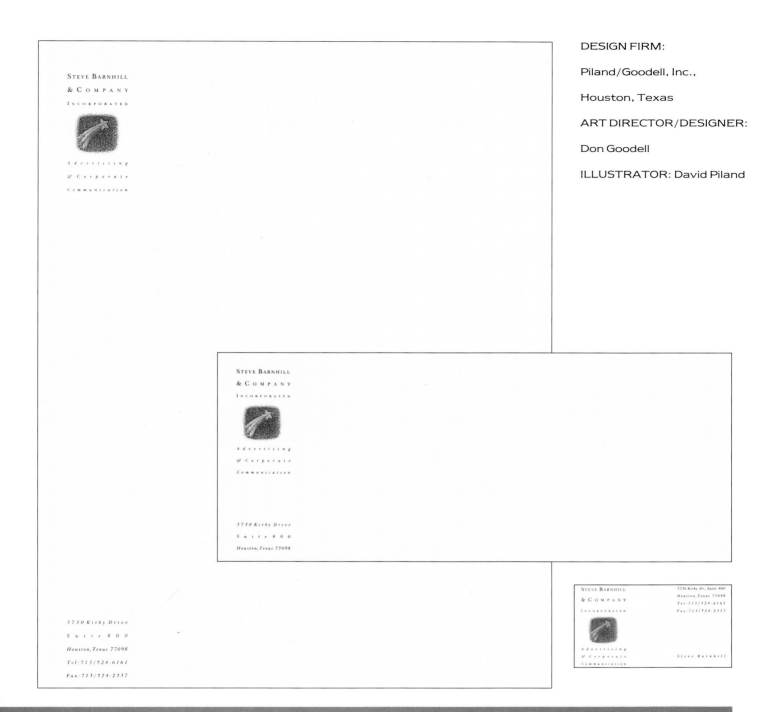

DESIGN FIRM:

Piland/Goodell, Inc.,

Houston, Texas

ART DIRECTOR/DESIGNER:

Don Goodell

ILLUSTRATOR: David Piland

## Steve Barnhill & Company, Inc. (Advertising & Corporate Communications)

DESIGN FIRM:

Studio Dudeō, Minneapolis,

Minnesota

ART DIRECTORS/DESIGNERS:

Susan Serstock,

Rick Peterson

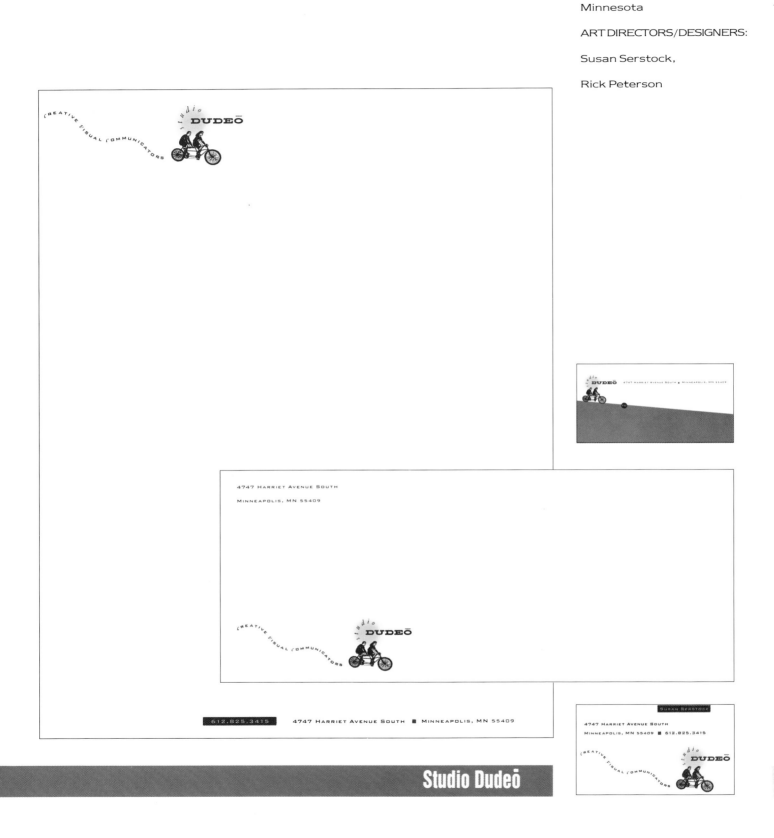

Studio Dudeō

DESIGN FIRM:
Gardner + Greteman,
Wichita, Kansas
CREATIVE DIRECTORS/
ART DIRECTORS:
Bill Gardner, Sonia
Greteman
DESIGNERS: Bill Gardner,
Sonia Greteman, Karen
Hogan
ILLUSTRATOR:
Mark Chickinelli
CLIENT DIRECTION:
Shelley Nehrt

300 N. MARTINGALE RD. STE. 250

SCHAUMBURG, ILLINOIS 60173

TELEPHONE 708 240 3200

FACSIMILE 708 240 3160

THERMOS.
N I S S A N

## Thermos Nissan (Thermal Products)

175

**WILLINGTOWN CONSTRUCTION**

P.O. BOX 4
YORKLYN,
DELAWARE
19736

3 0 2 • 2 3 9 • 1 8 0 0

DESIGN FIRM:

Ross Design Inc.,

Wilmington , Delaware

ART DIRECTOR/DESIGNER/

ILLUSTRATOR: Tony Ross

**WILLINGTOWN CONSTRUCTION**

P.O. BOX 4
YORKLYN,
DELAWARE 19736

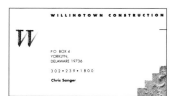

**WILLINGTOWN CONSTRUCTION**

P.O BOX 4
YORKLYN,
DELAWARE 19736

3 0 2 • 2 3 9 • 1 8 0 0

**Chris Sanger**

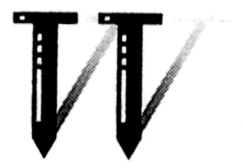

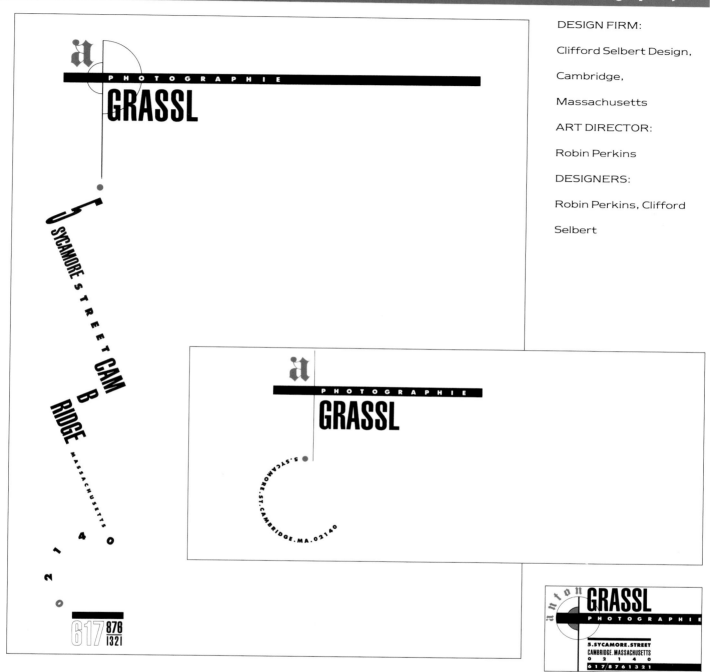

DESIGN FIRM:

Clifford Selbert Design,

Cambridge,

Massachusetts

ART DIRECTOR:

Robin Perkins

DESIGNERS:

Robin Perkins, Clifford

Selbert

## CREATIVE DIRECTORS ART DIRECTORS DESIGNERS

## ARTISTS
## COPYWRITERS
## ILLUSTRATORS
## LETTERERS
## PHOTOGRAPHERS
## PRINTERS/SEPARATORS
## TYPOGRAPHERS